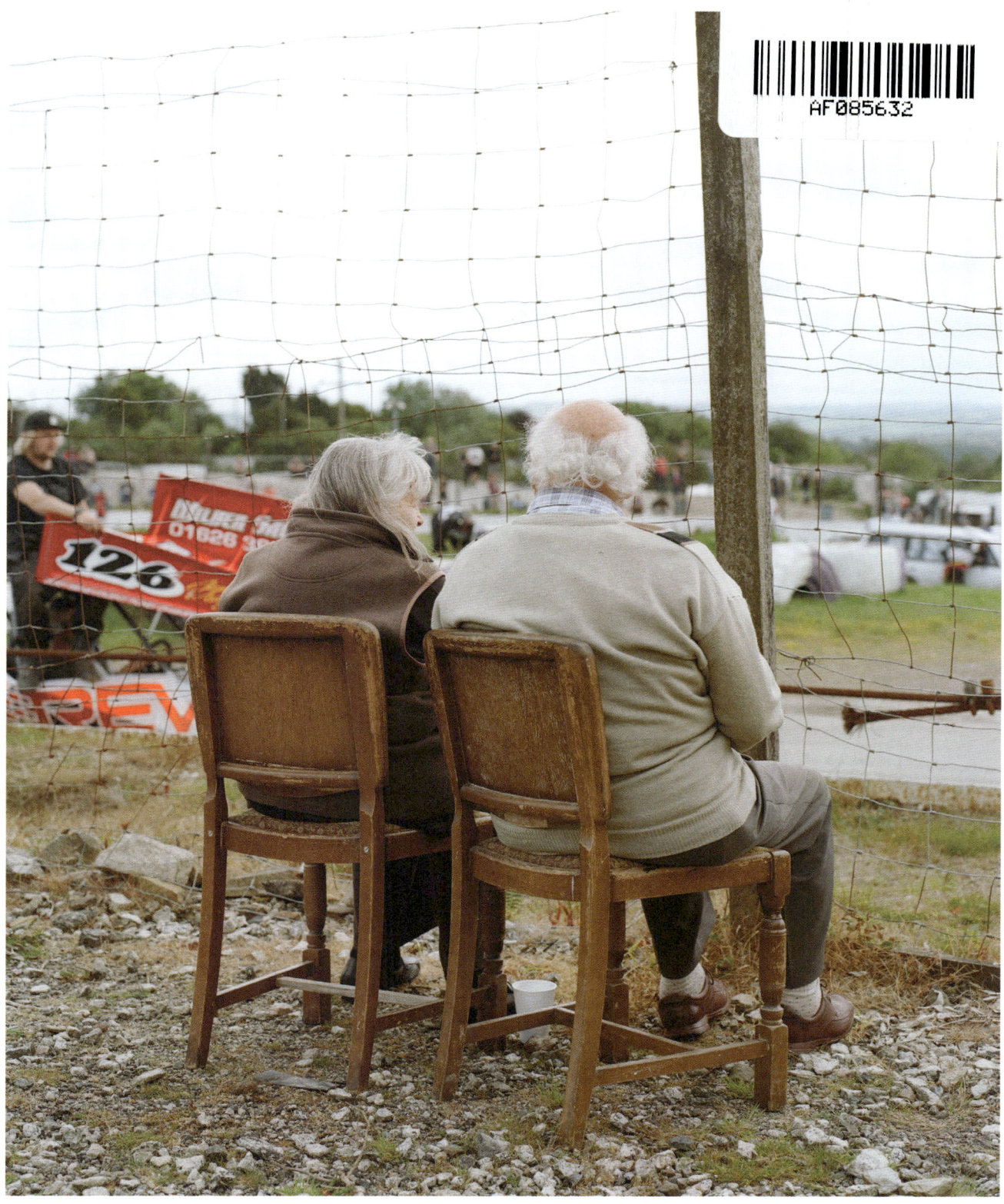

THE LAST RACEWAY

BECKY TYRRELL

GUEST EDITIONS

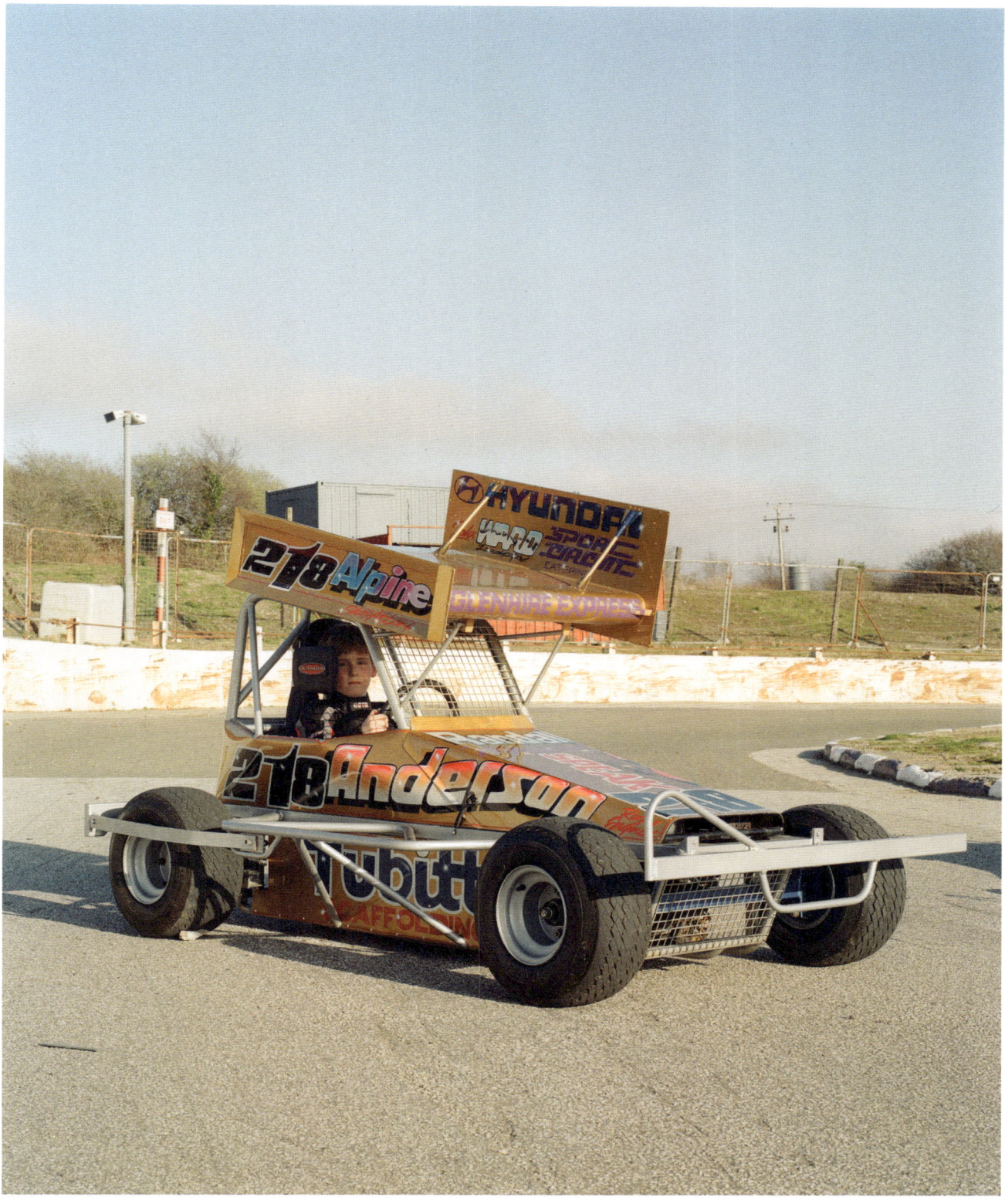

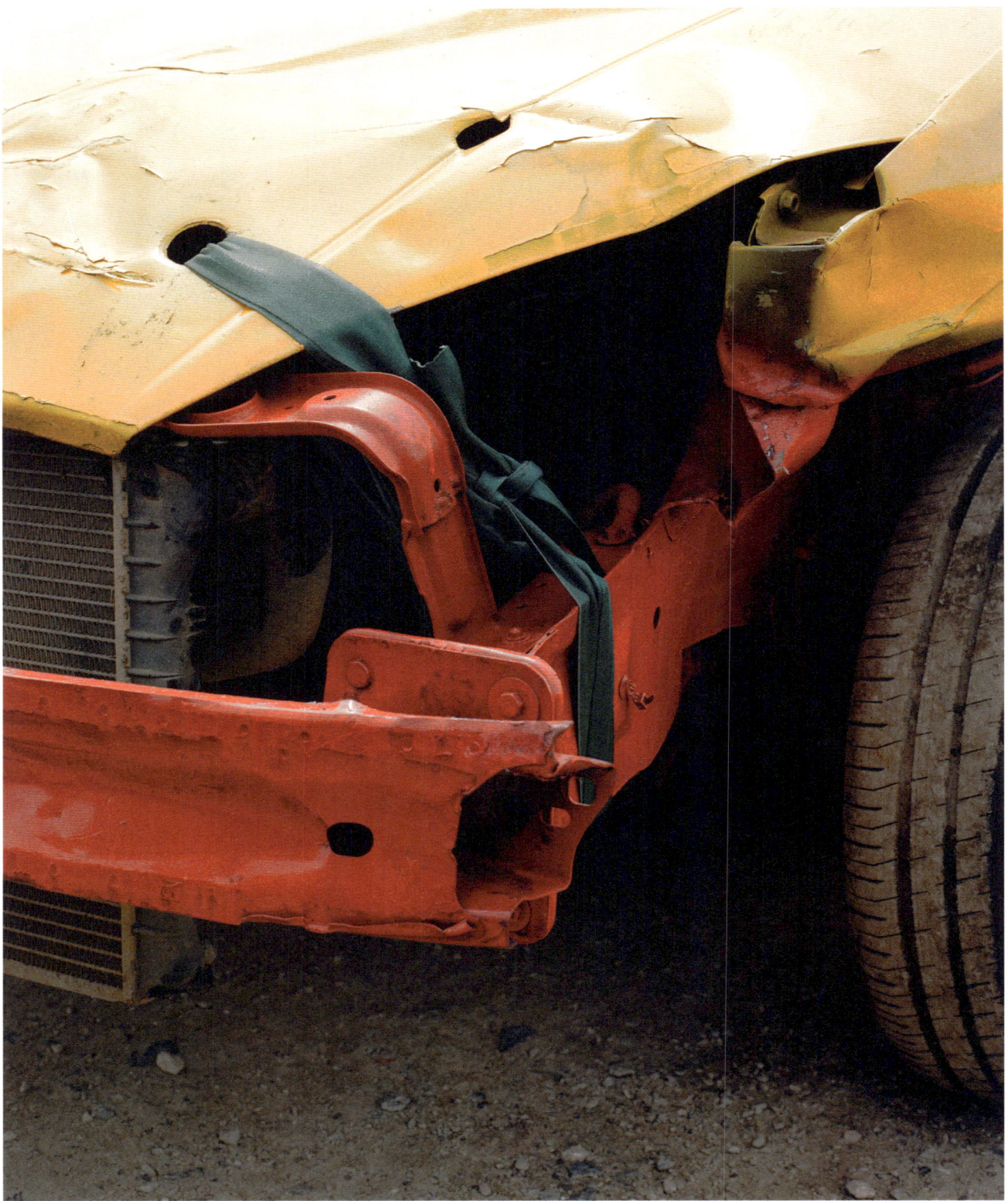

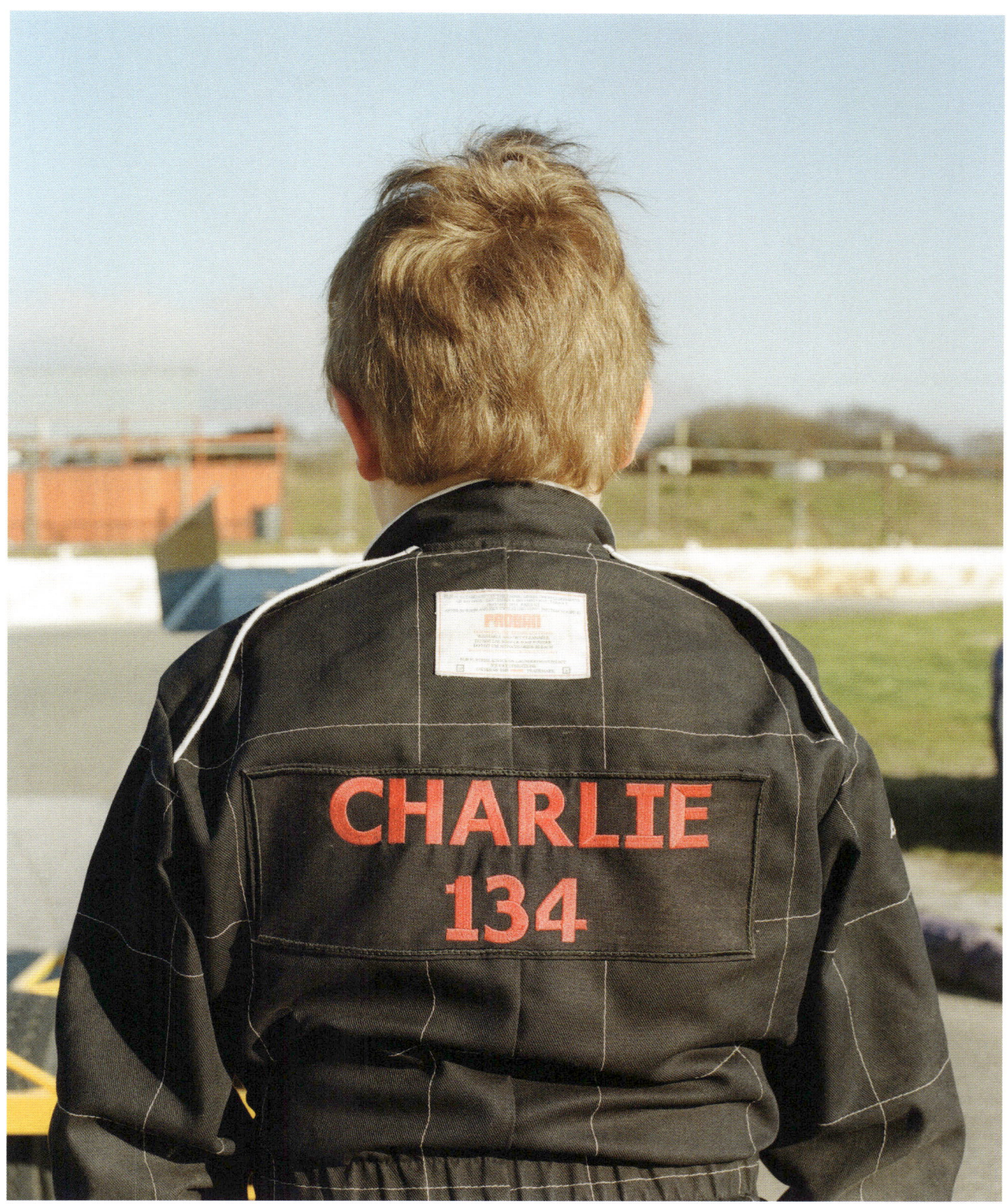

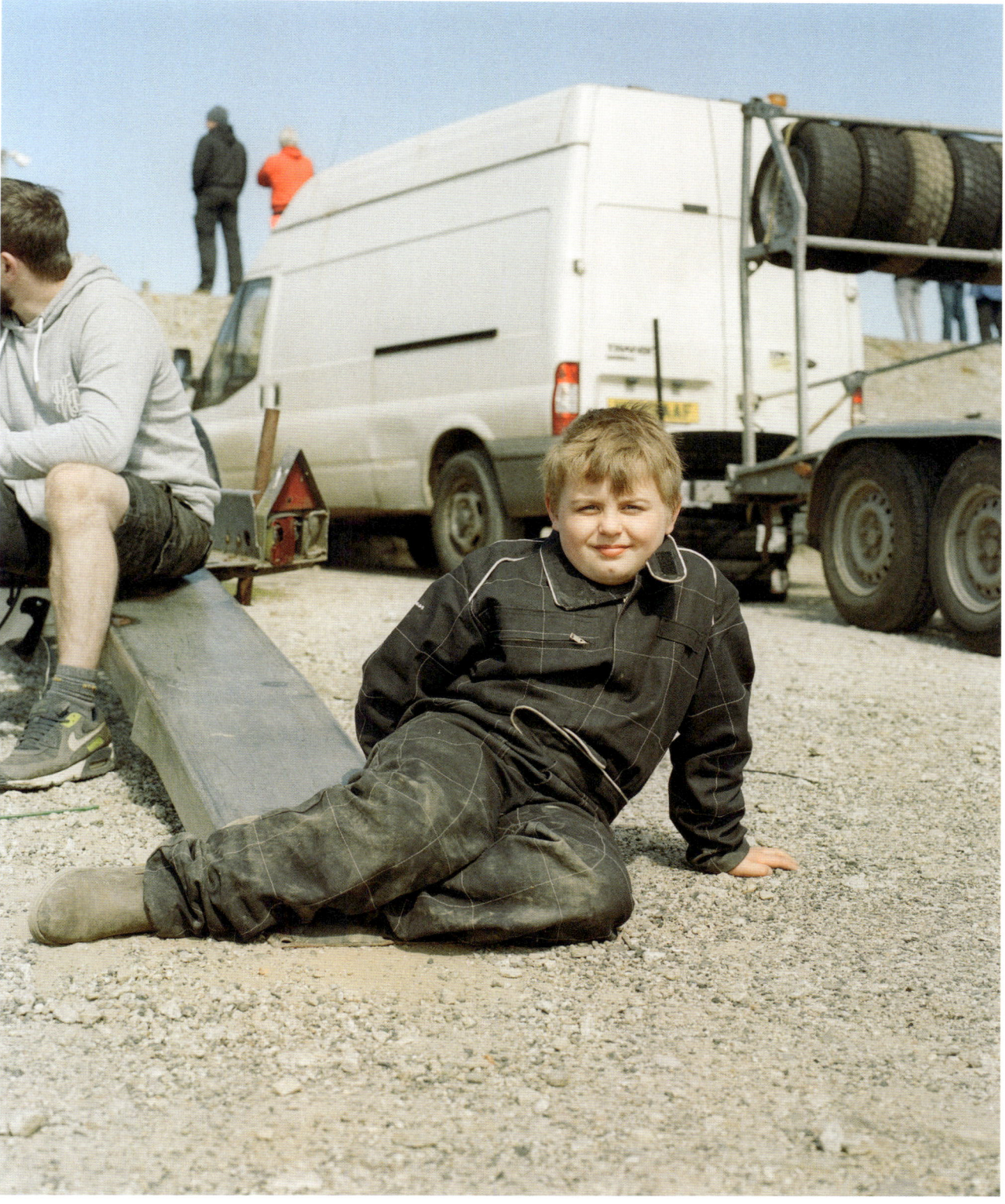

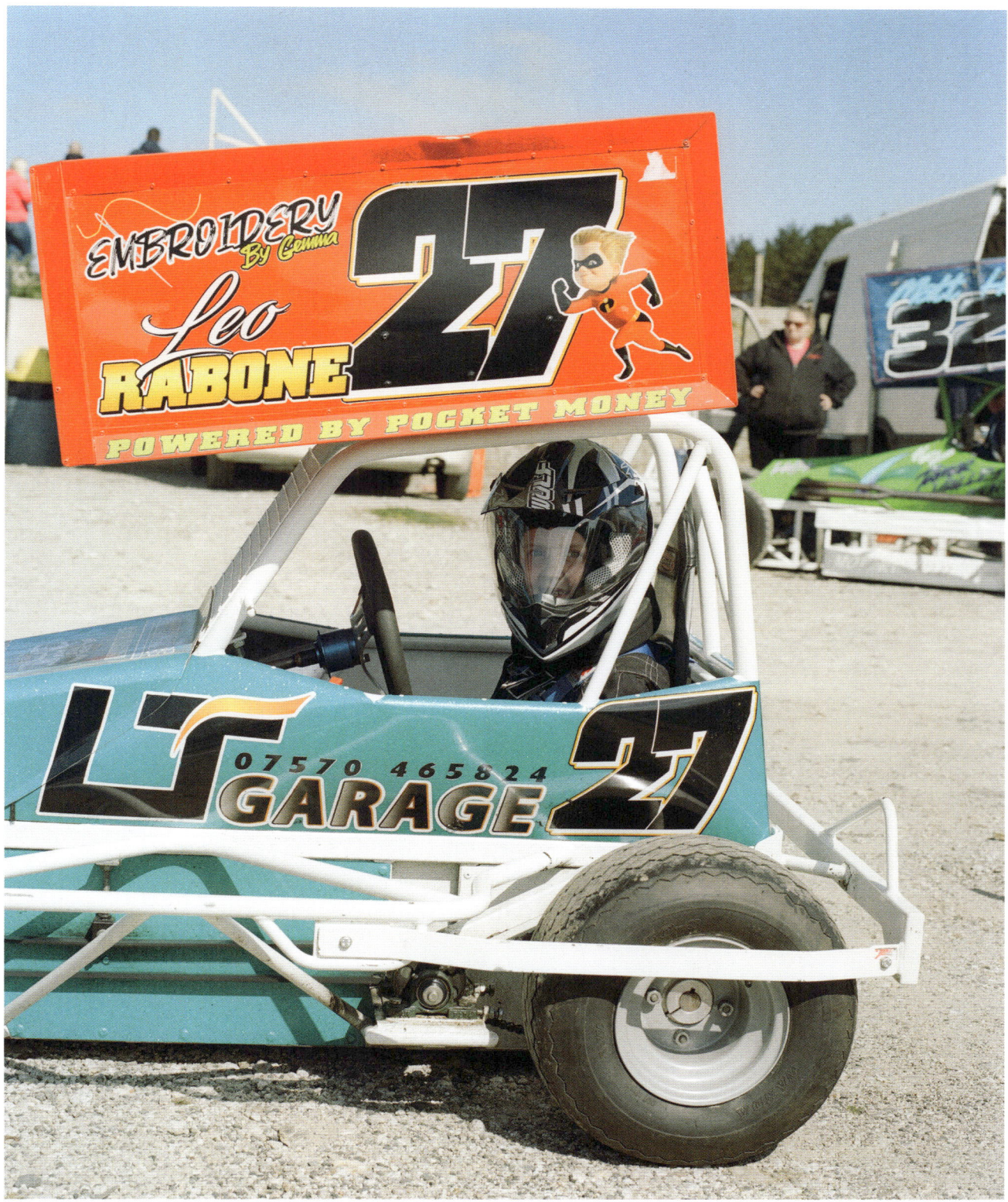

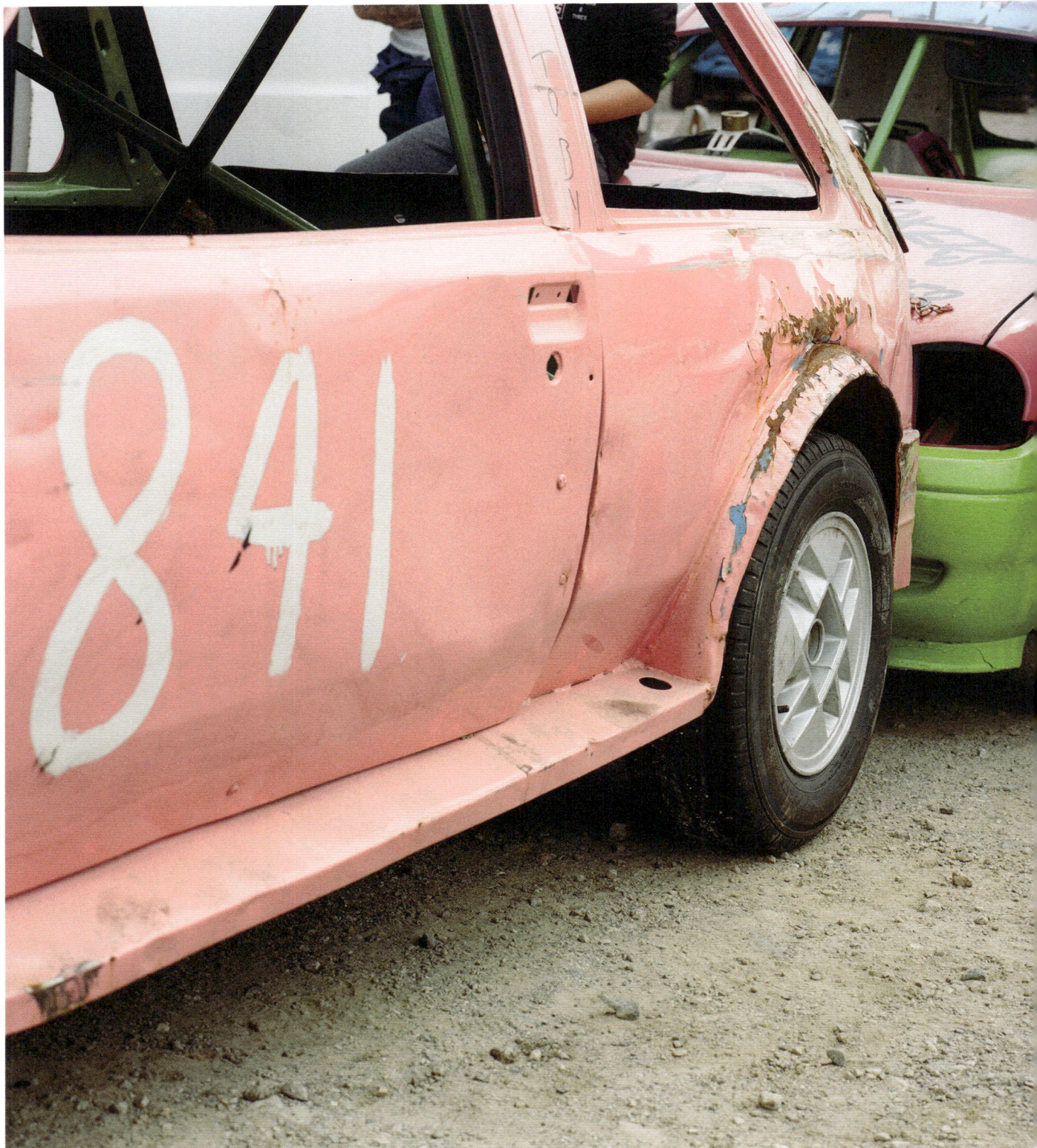

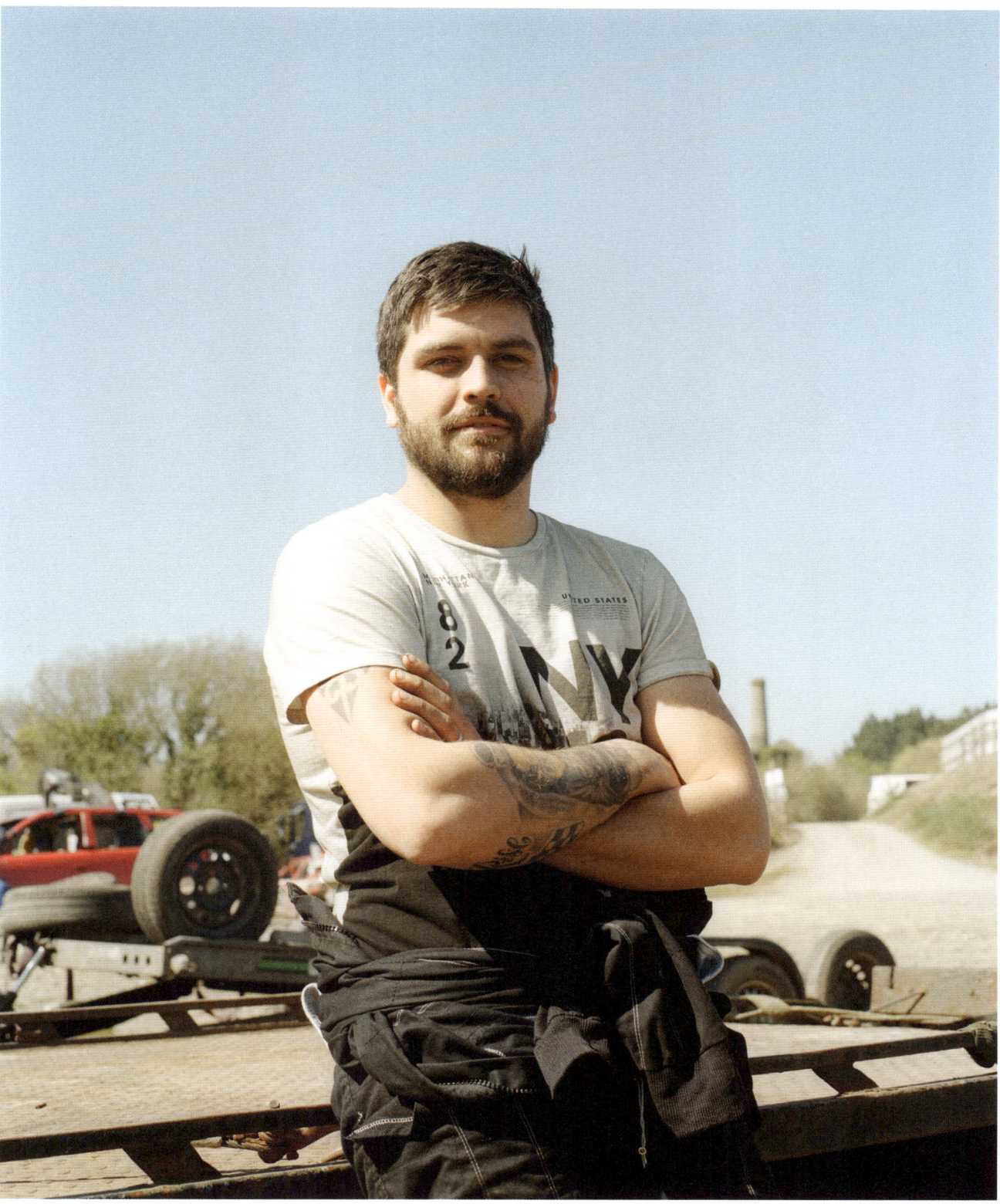

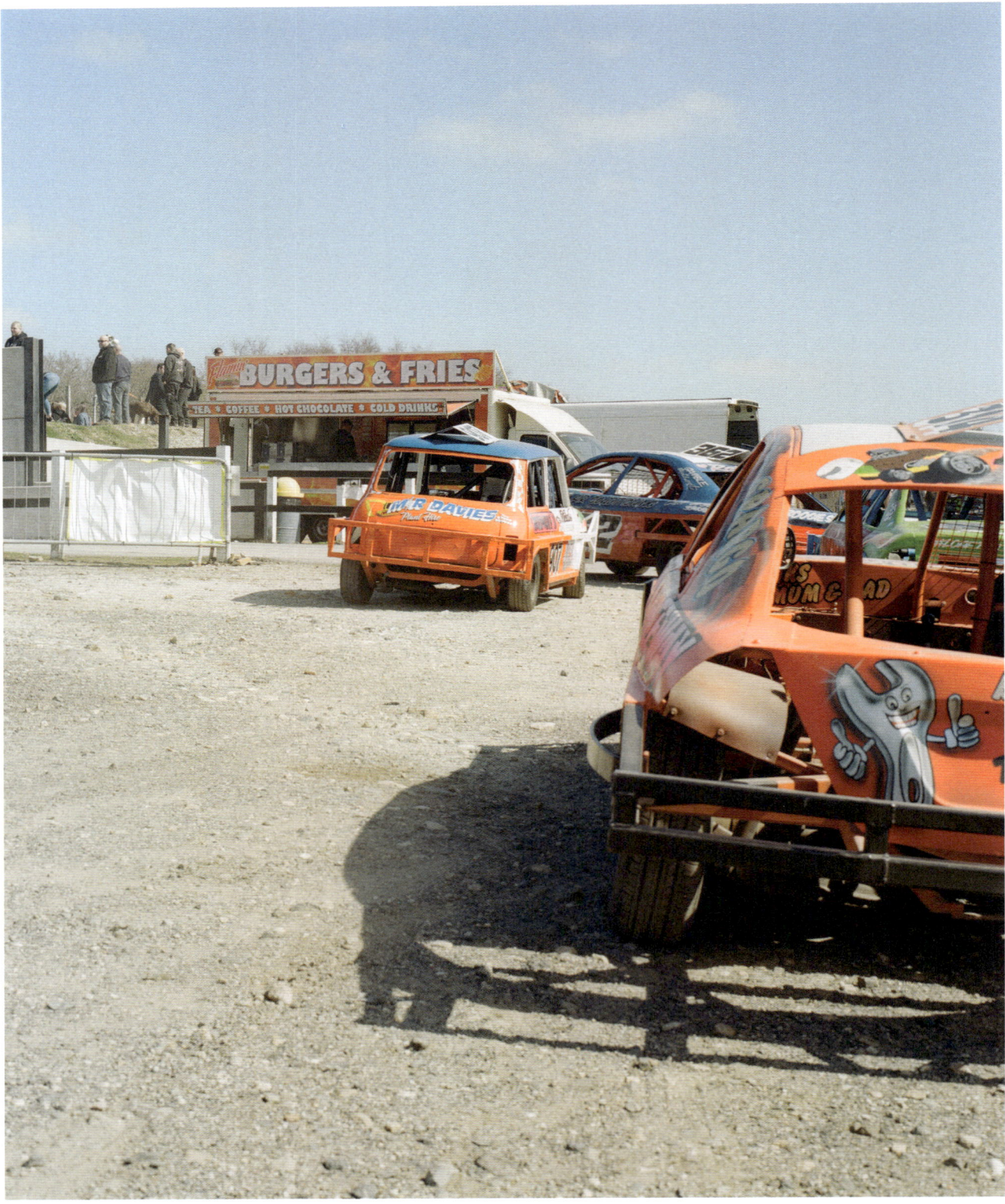

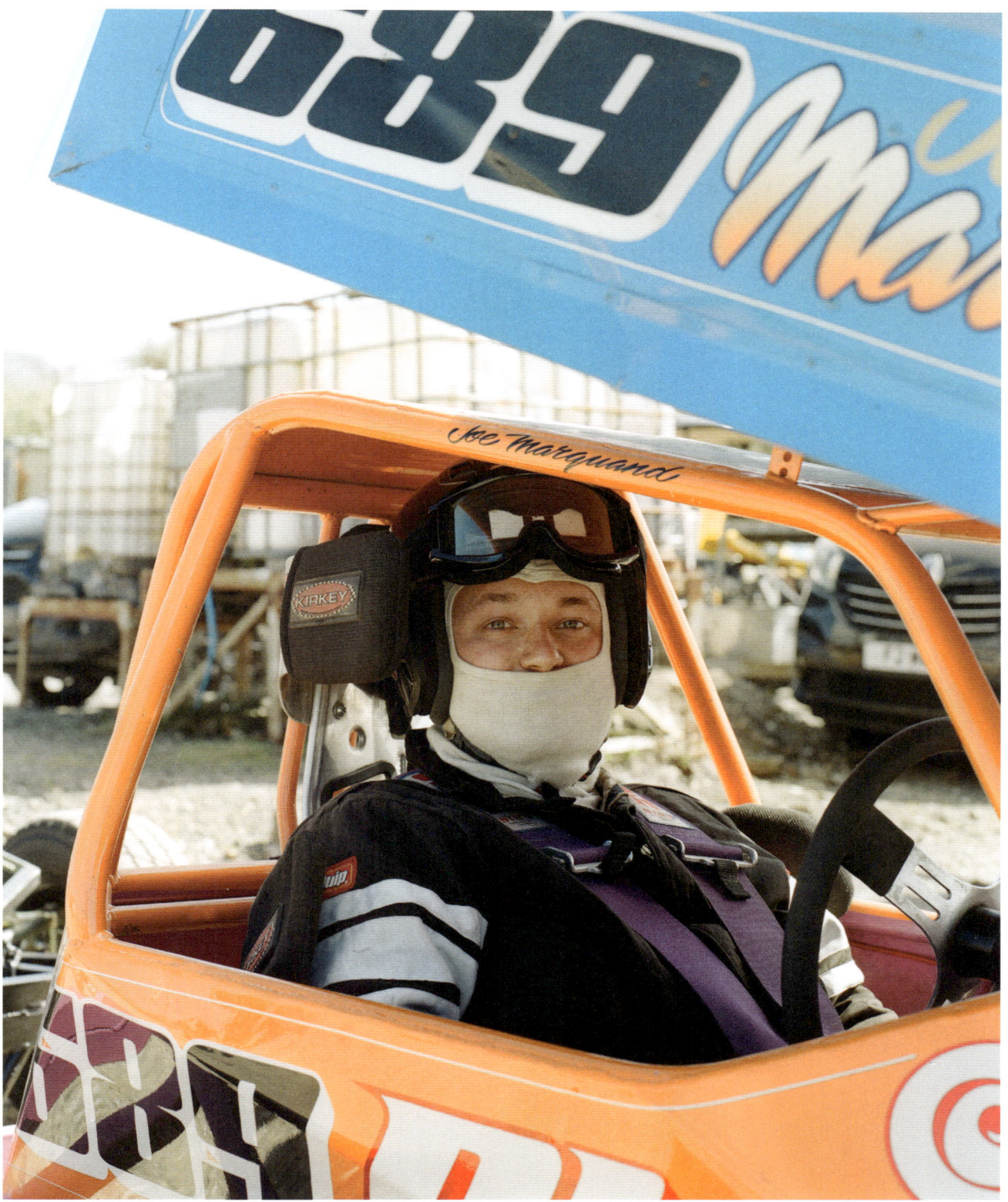

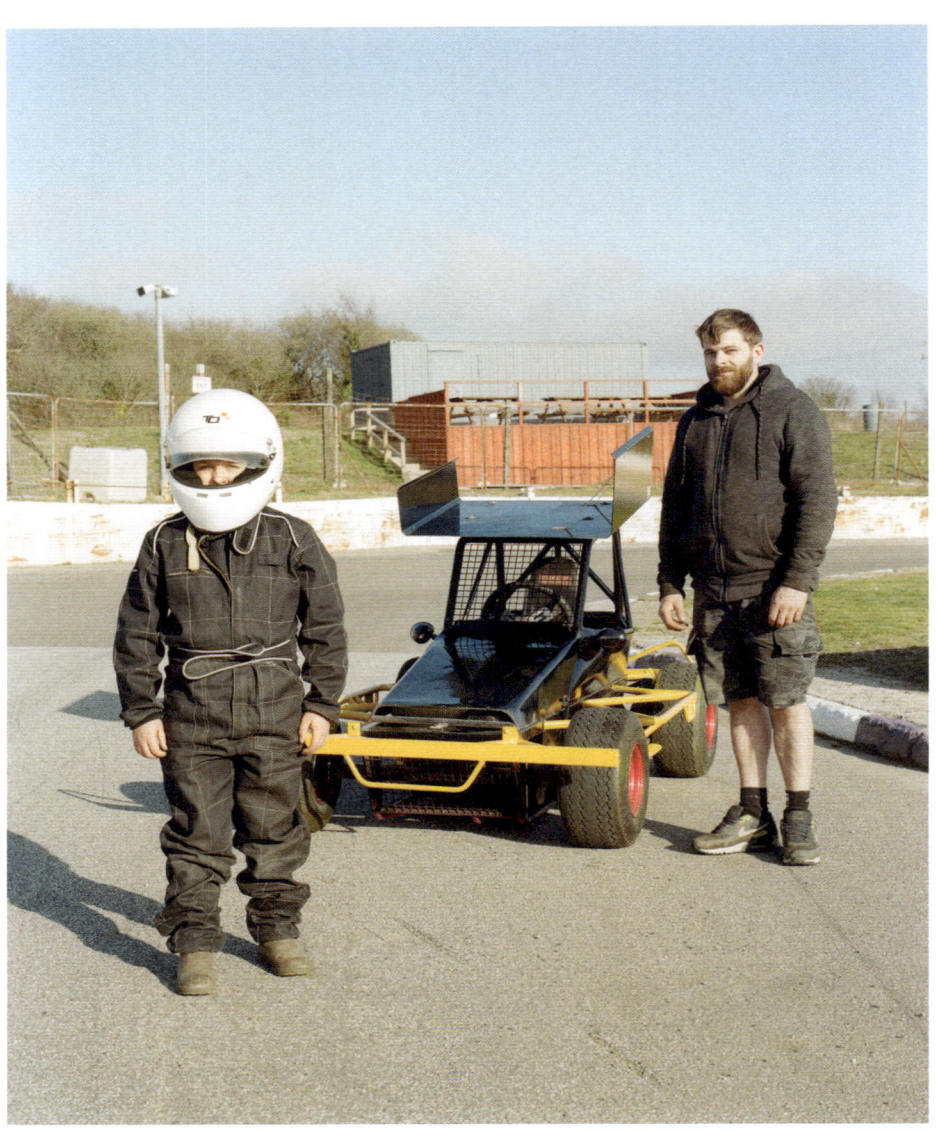

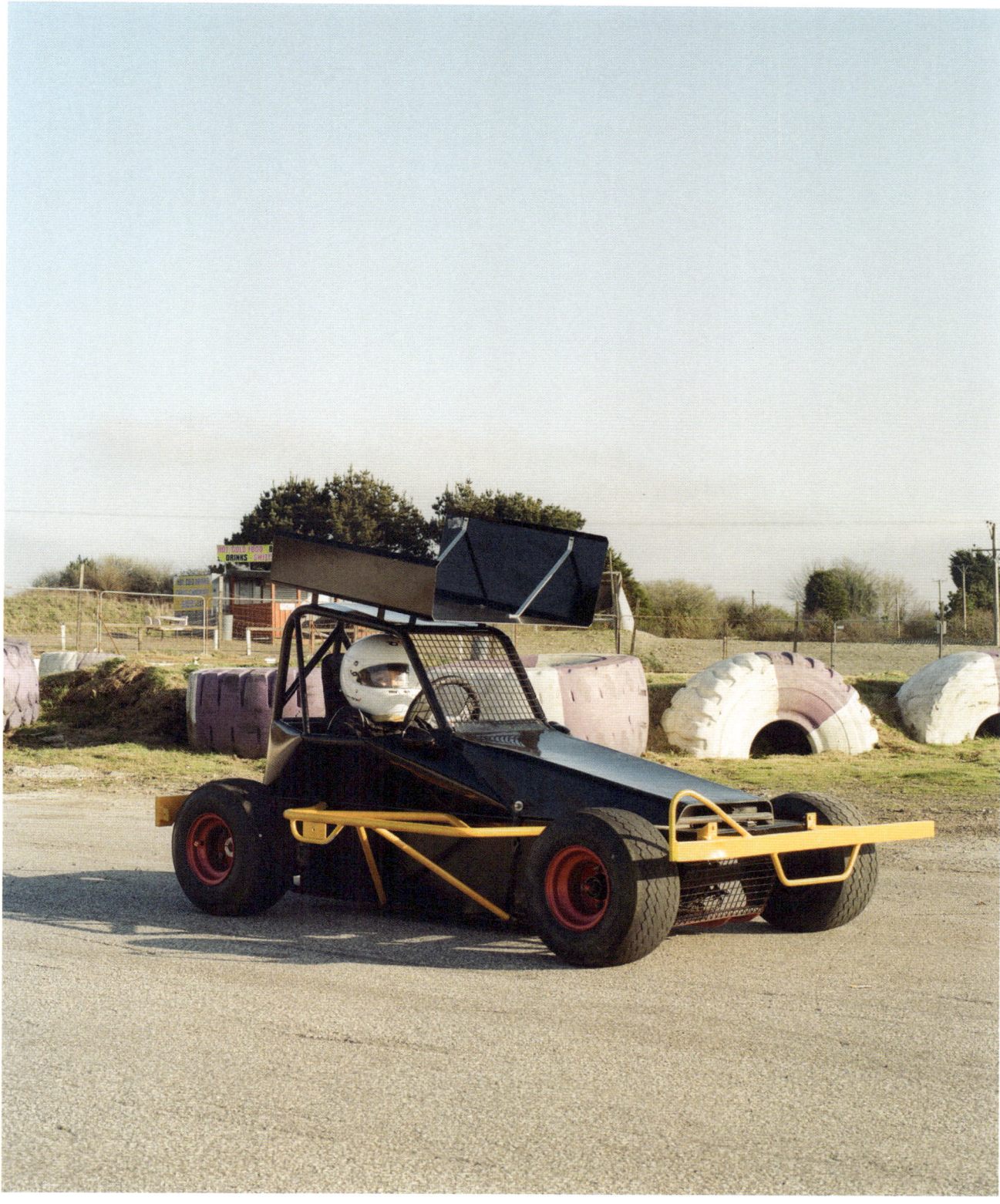

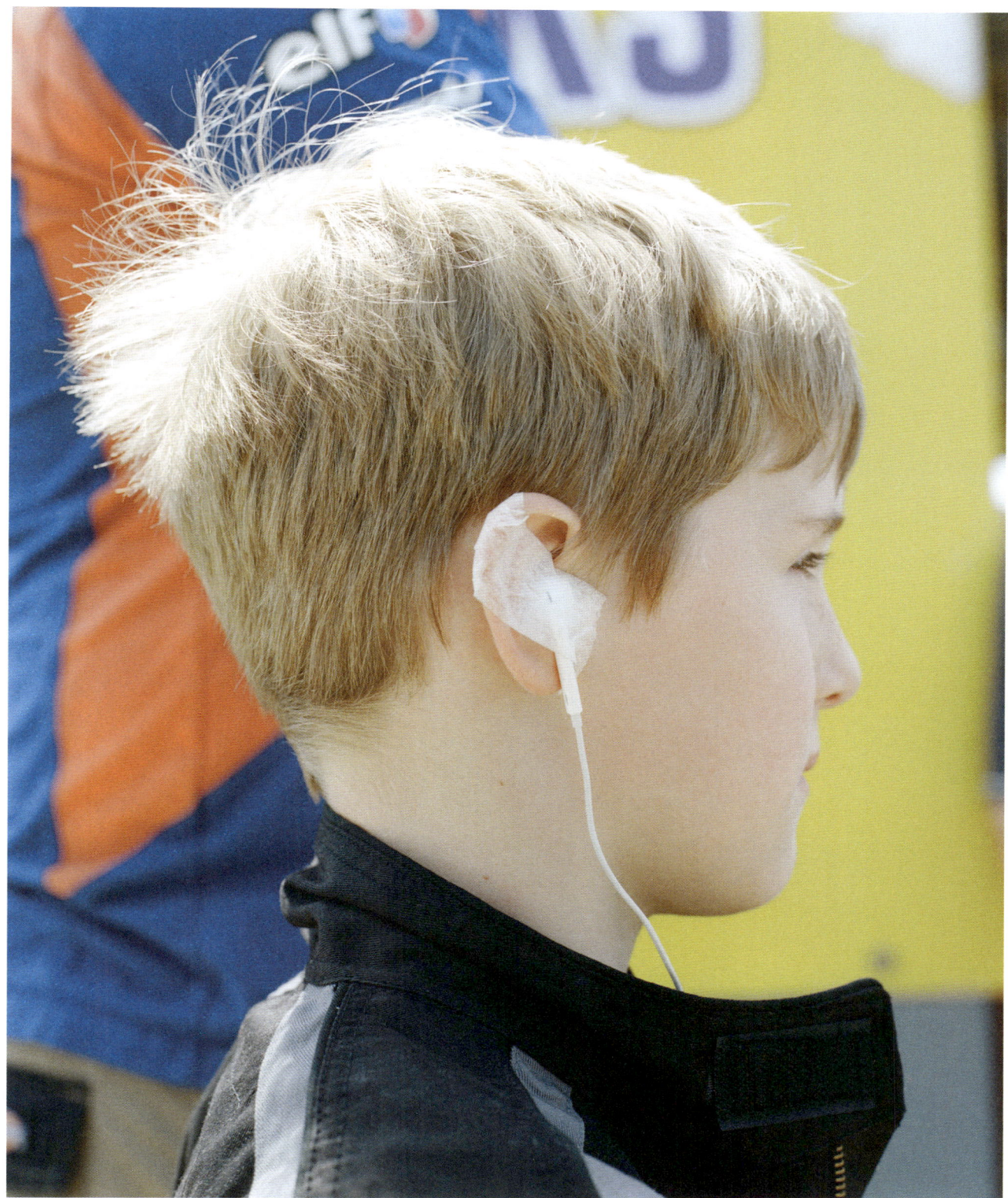

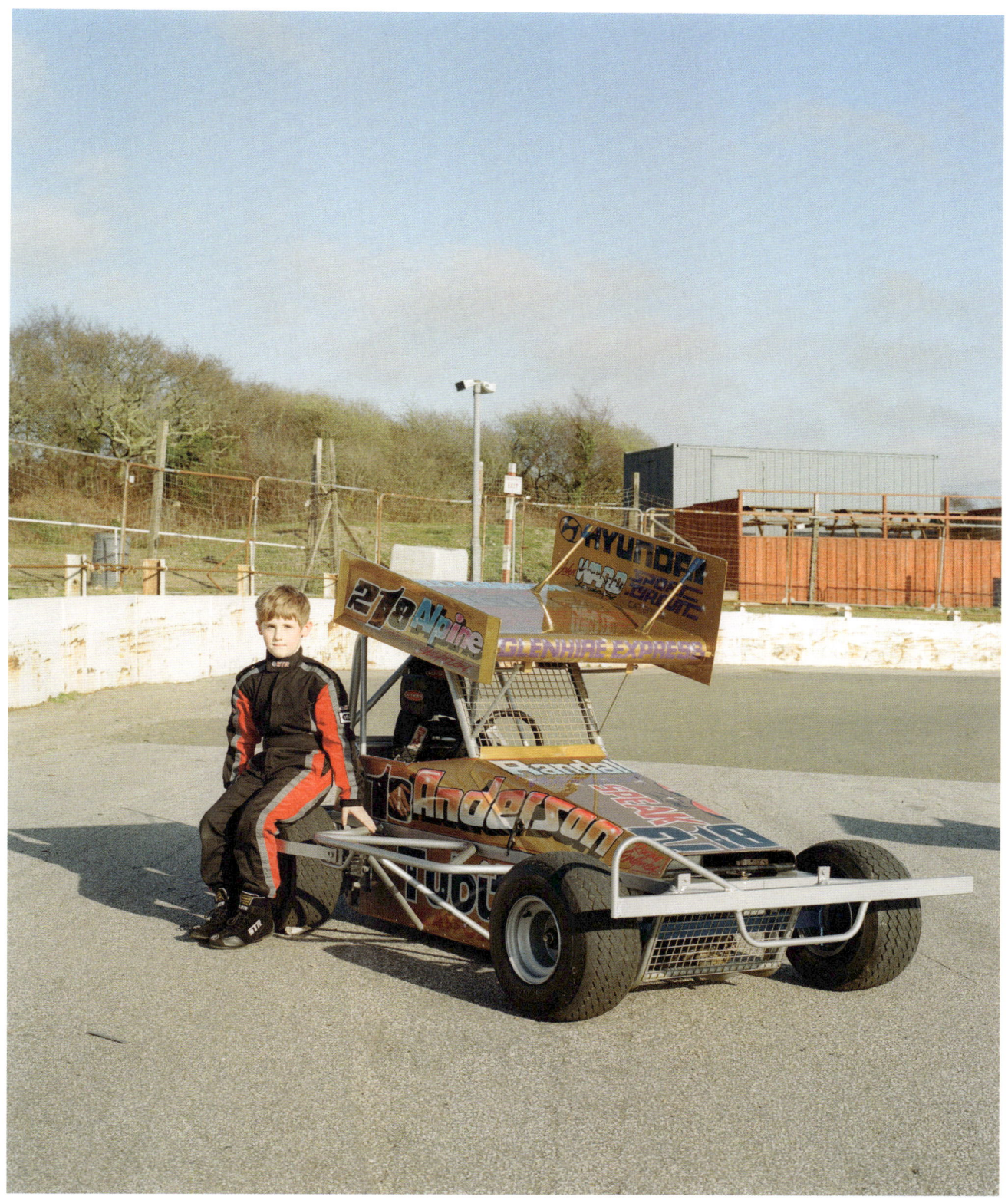

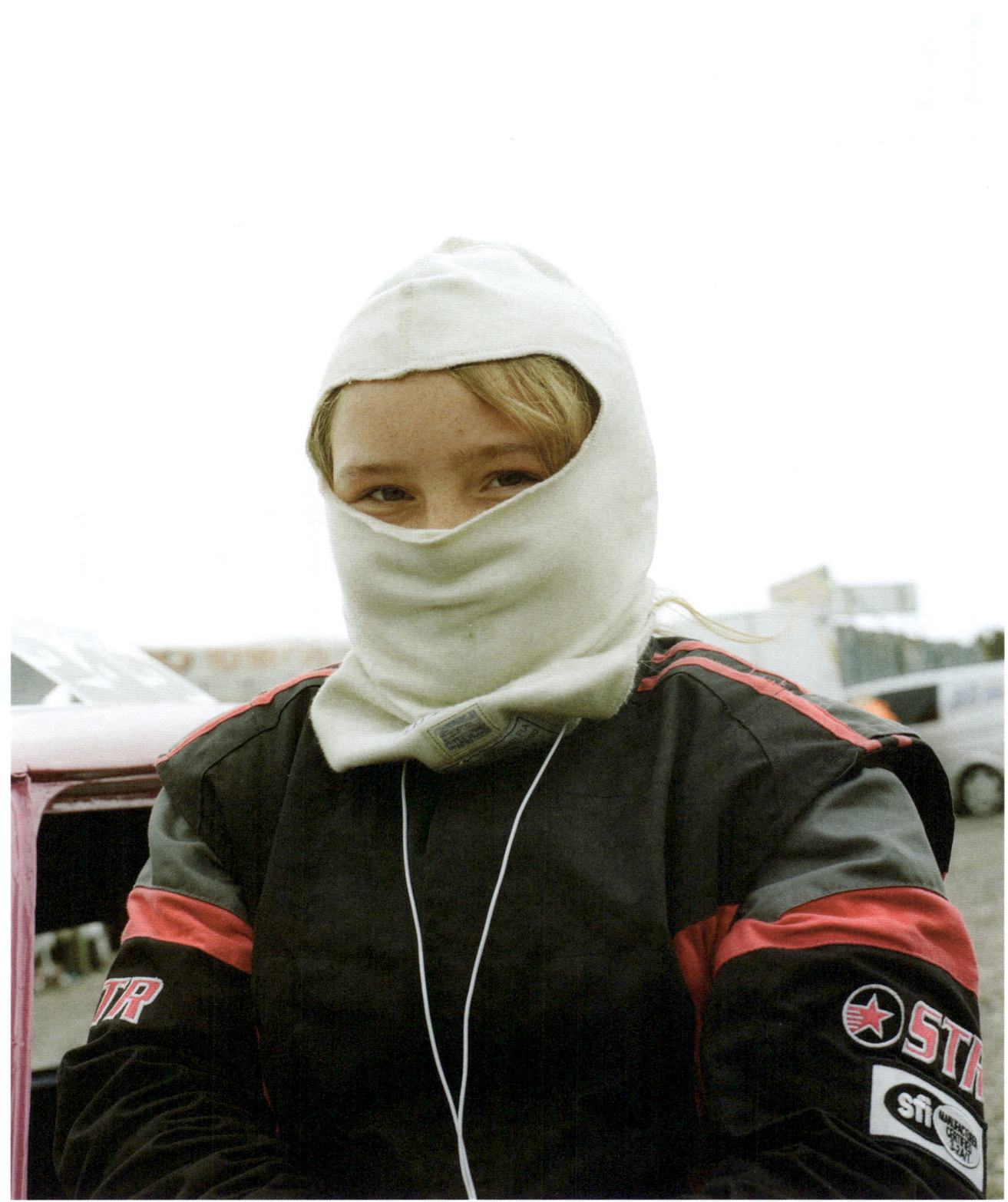

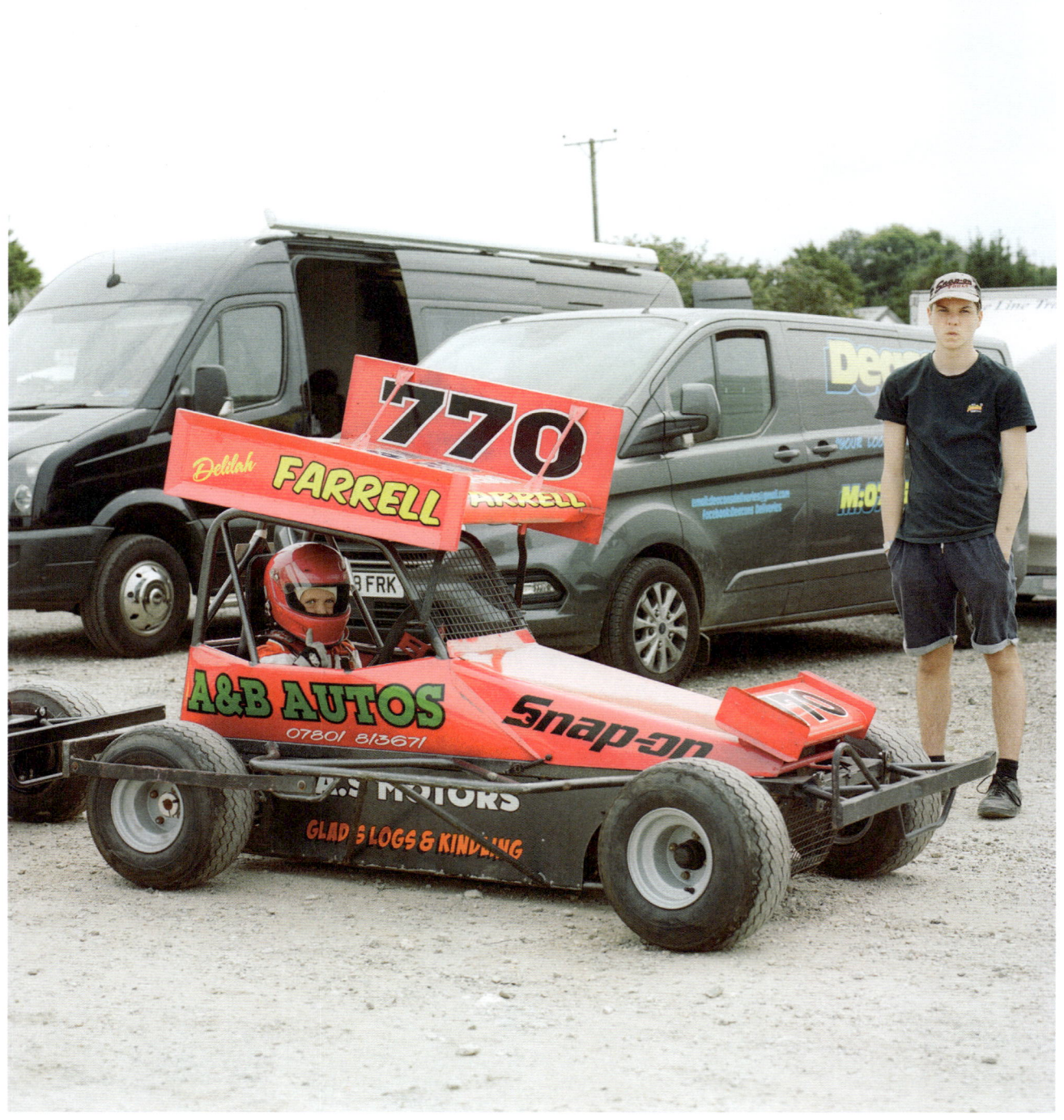

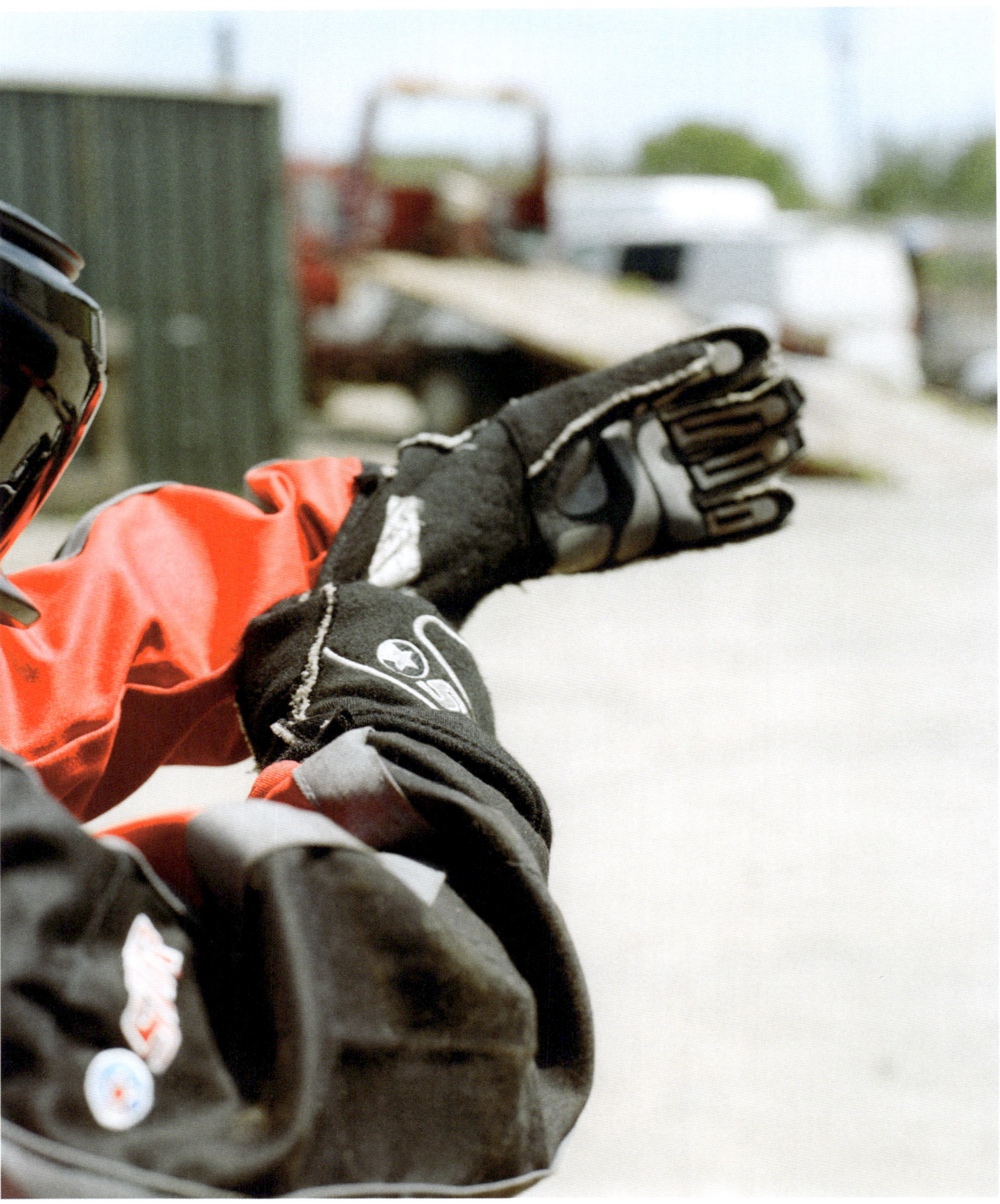

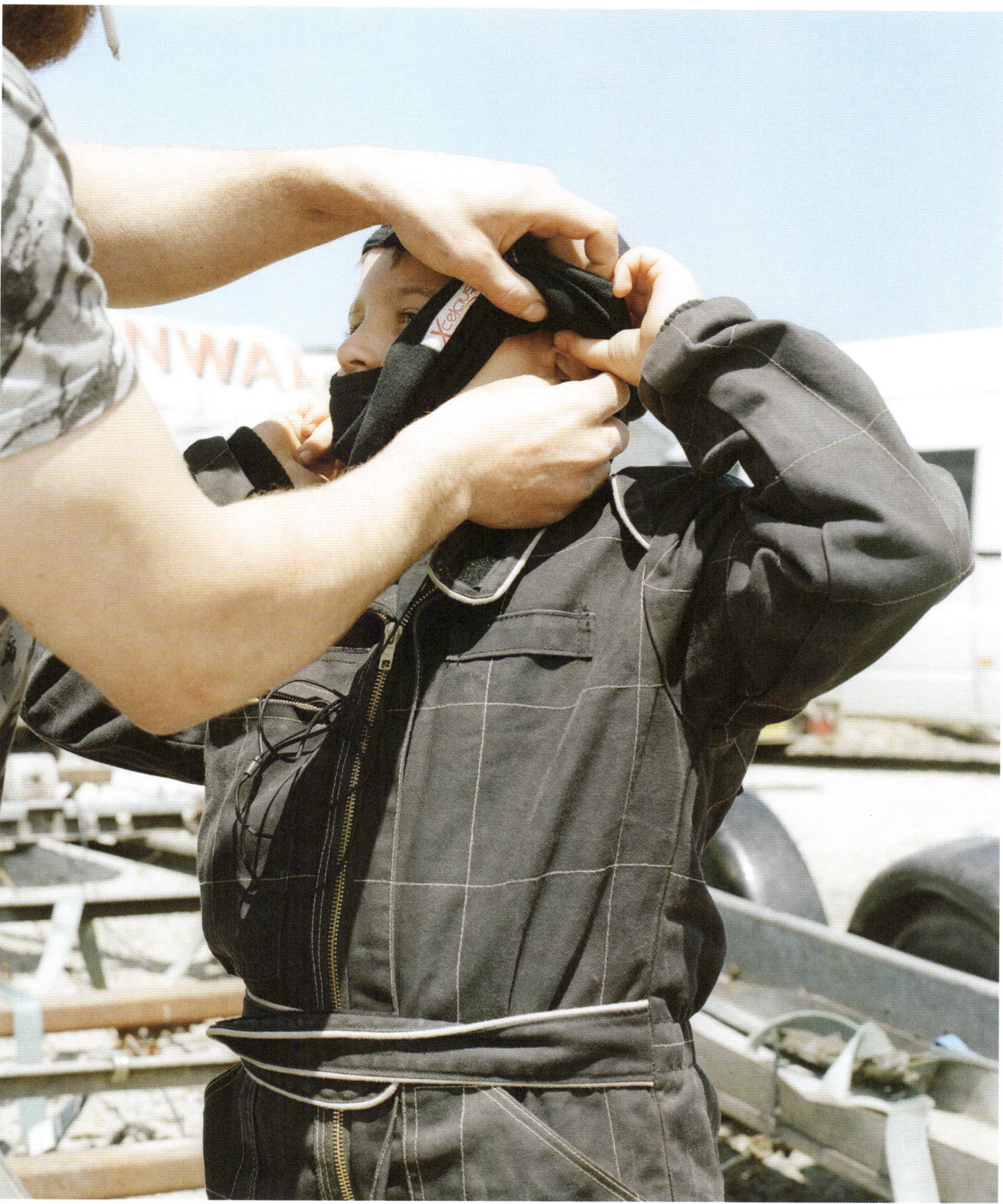

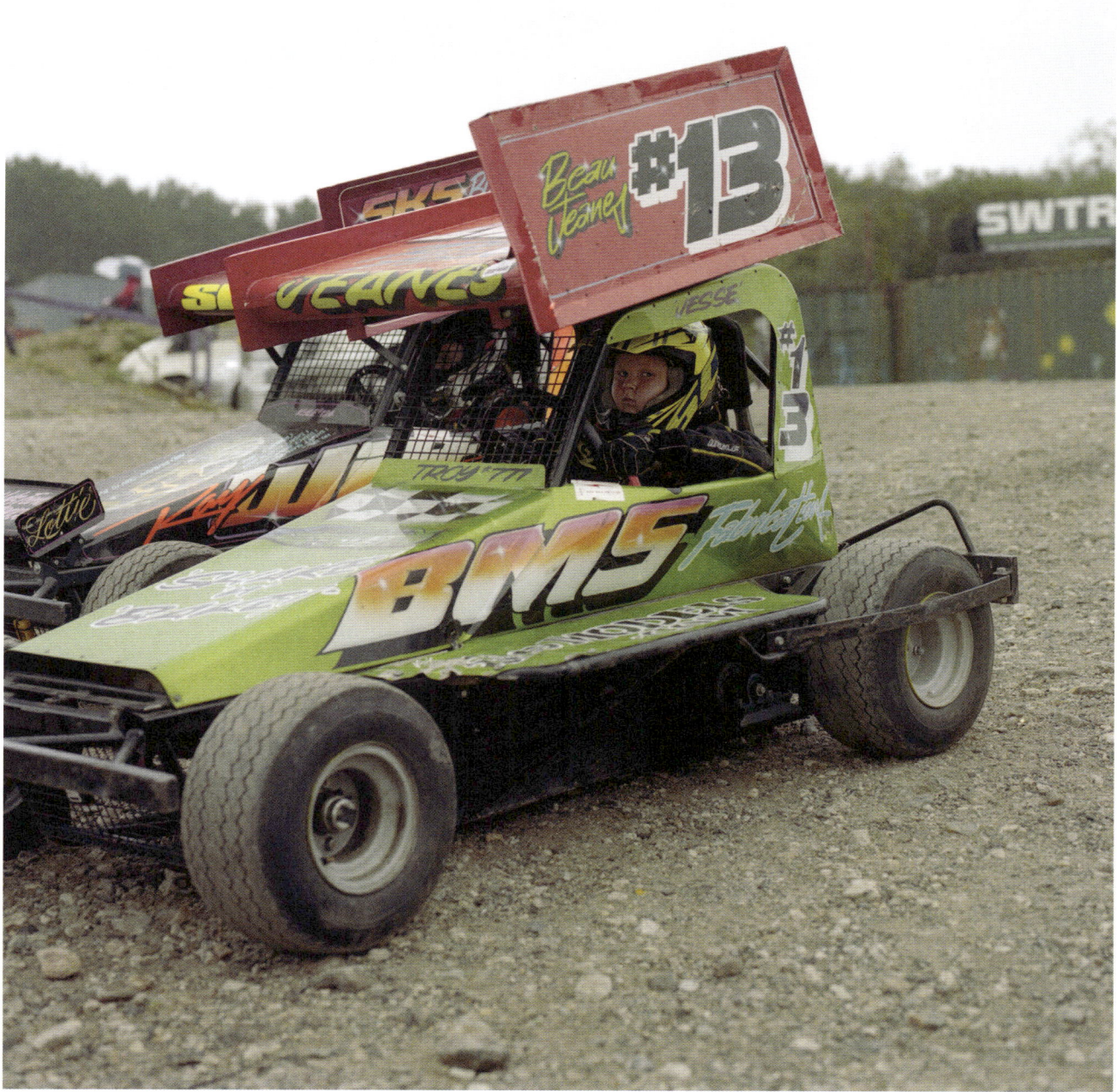

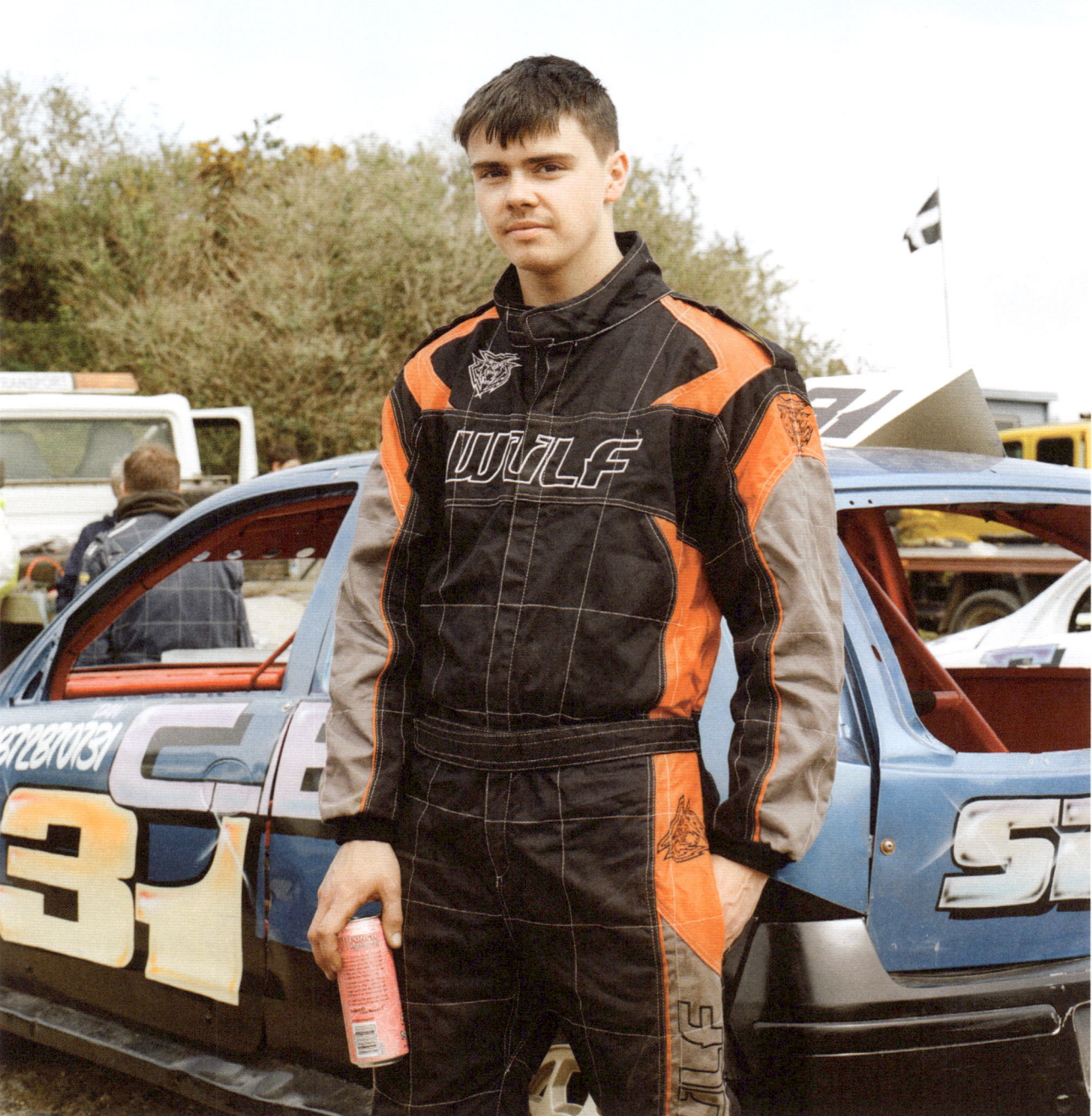

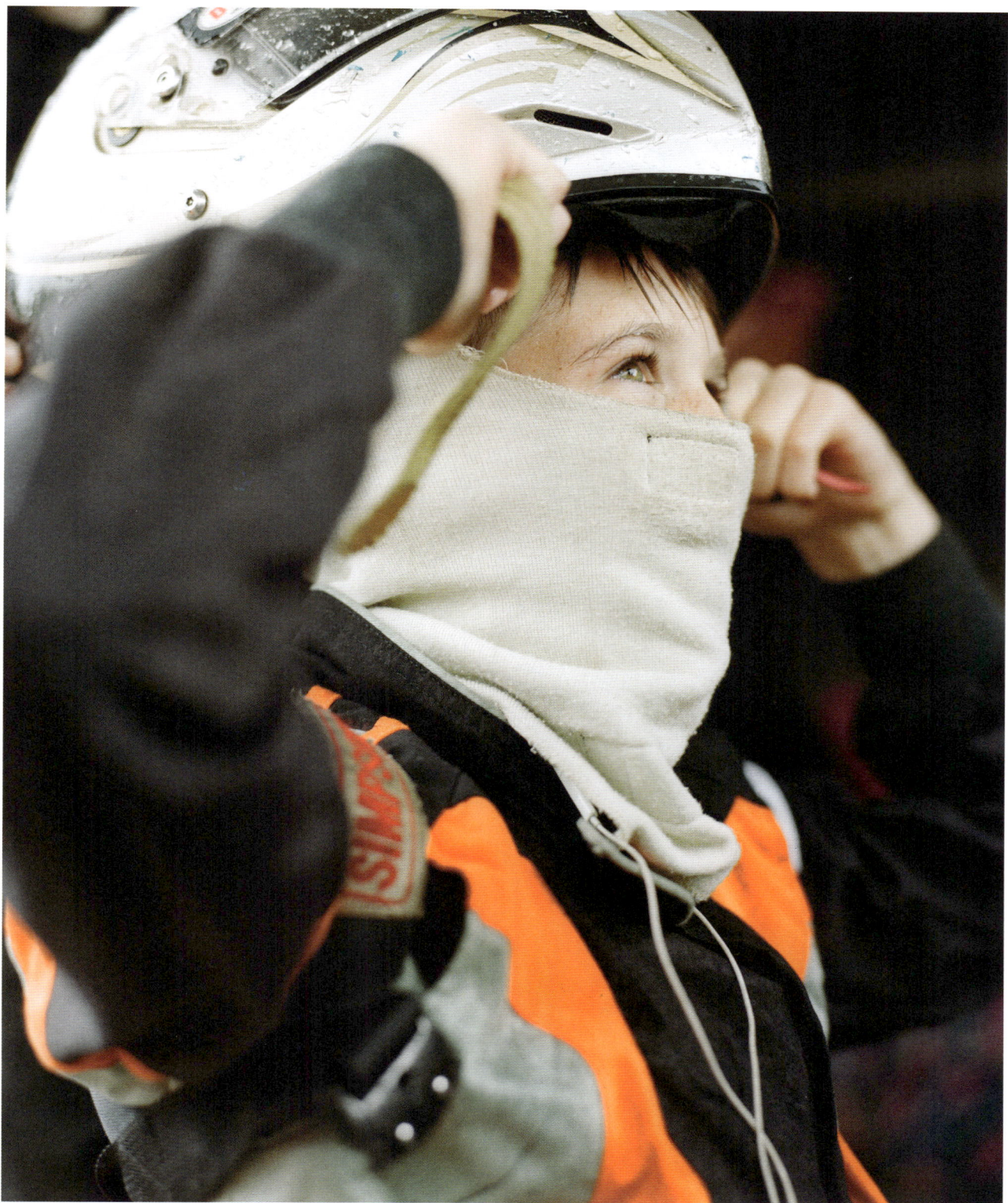

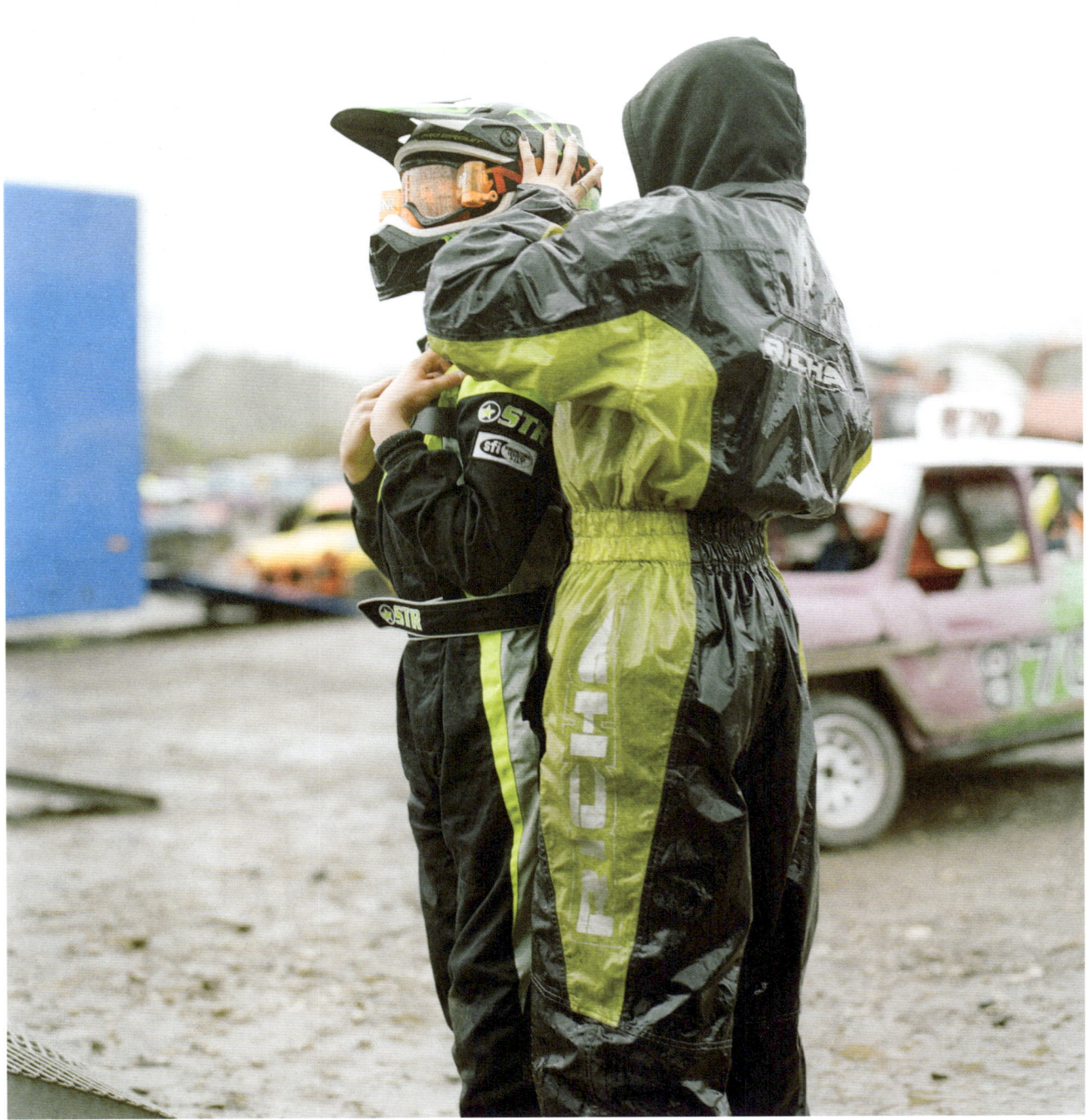

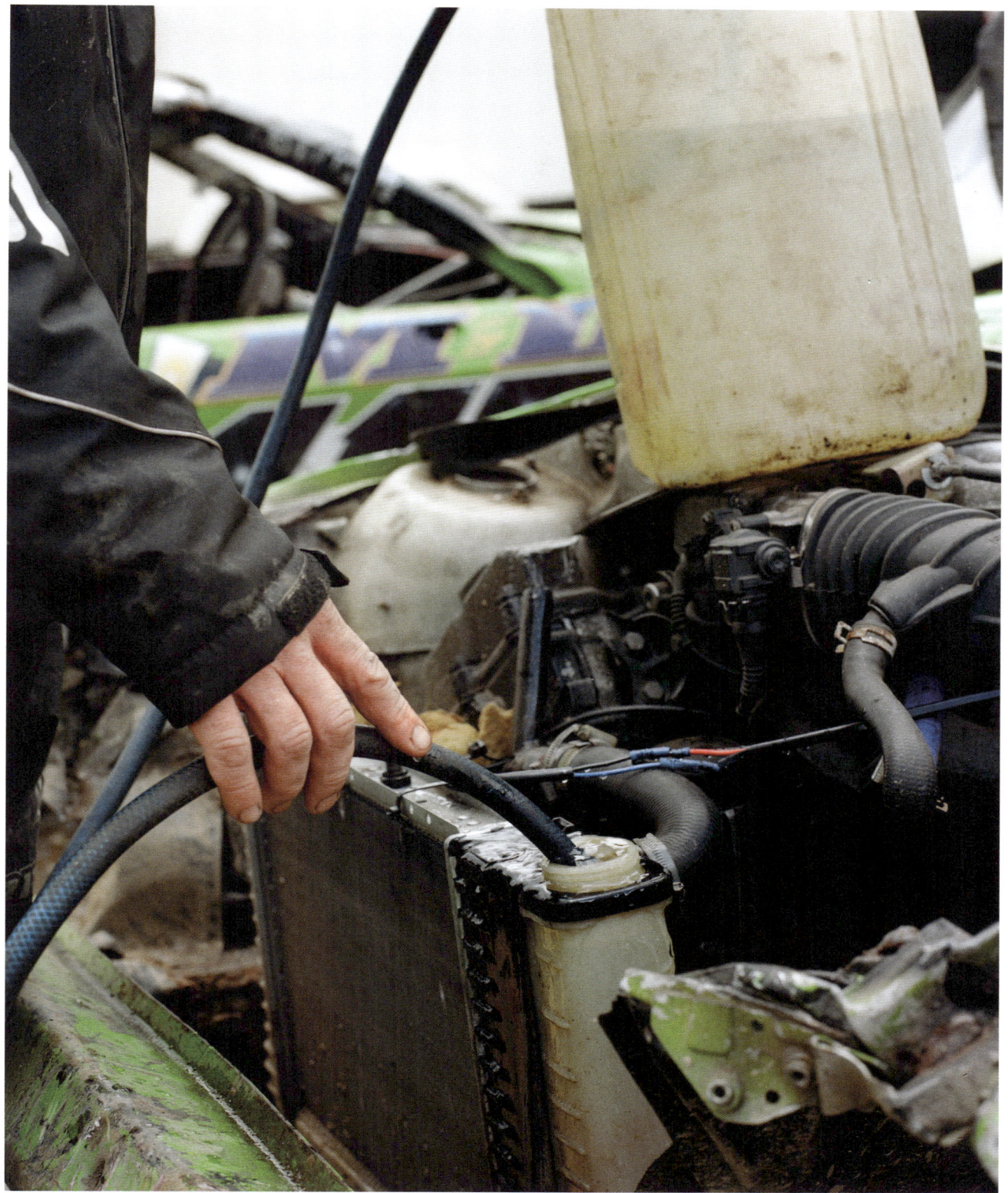

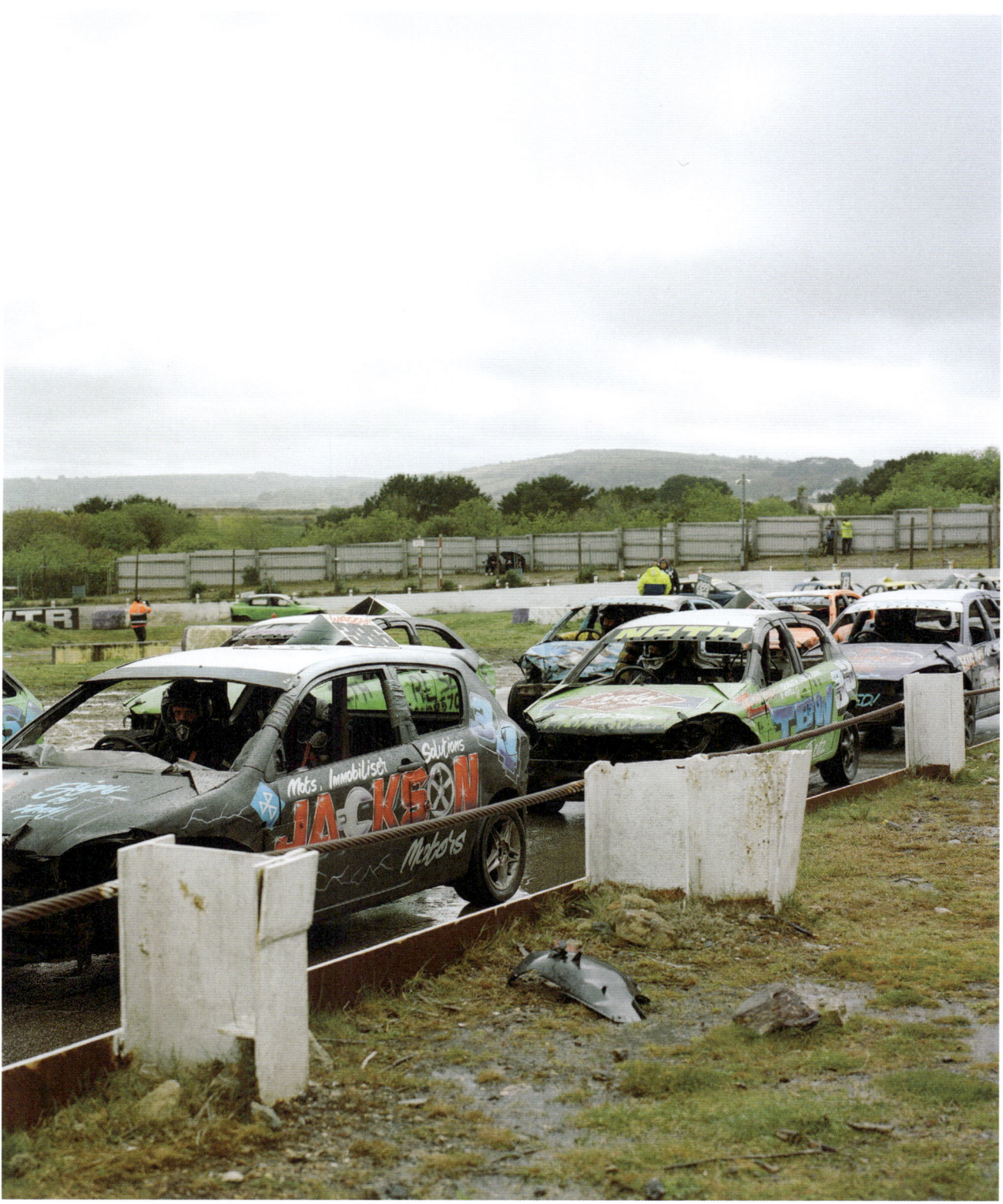

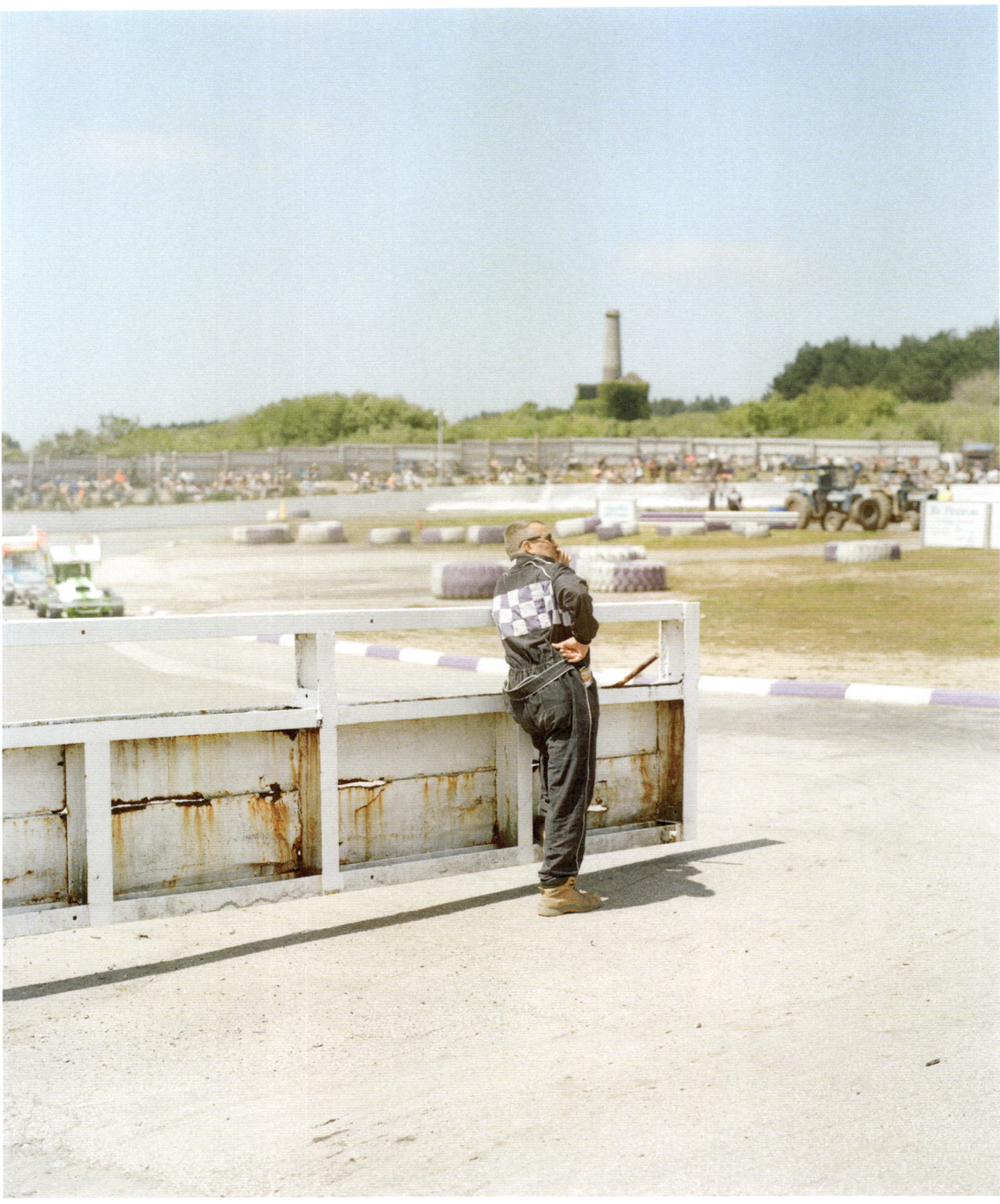

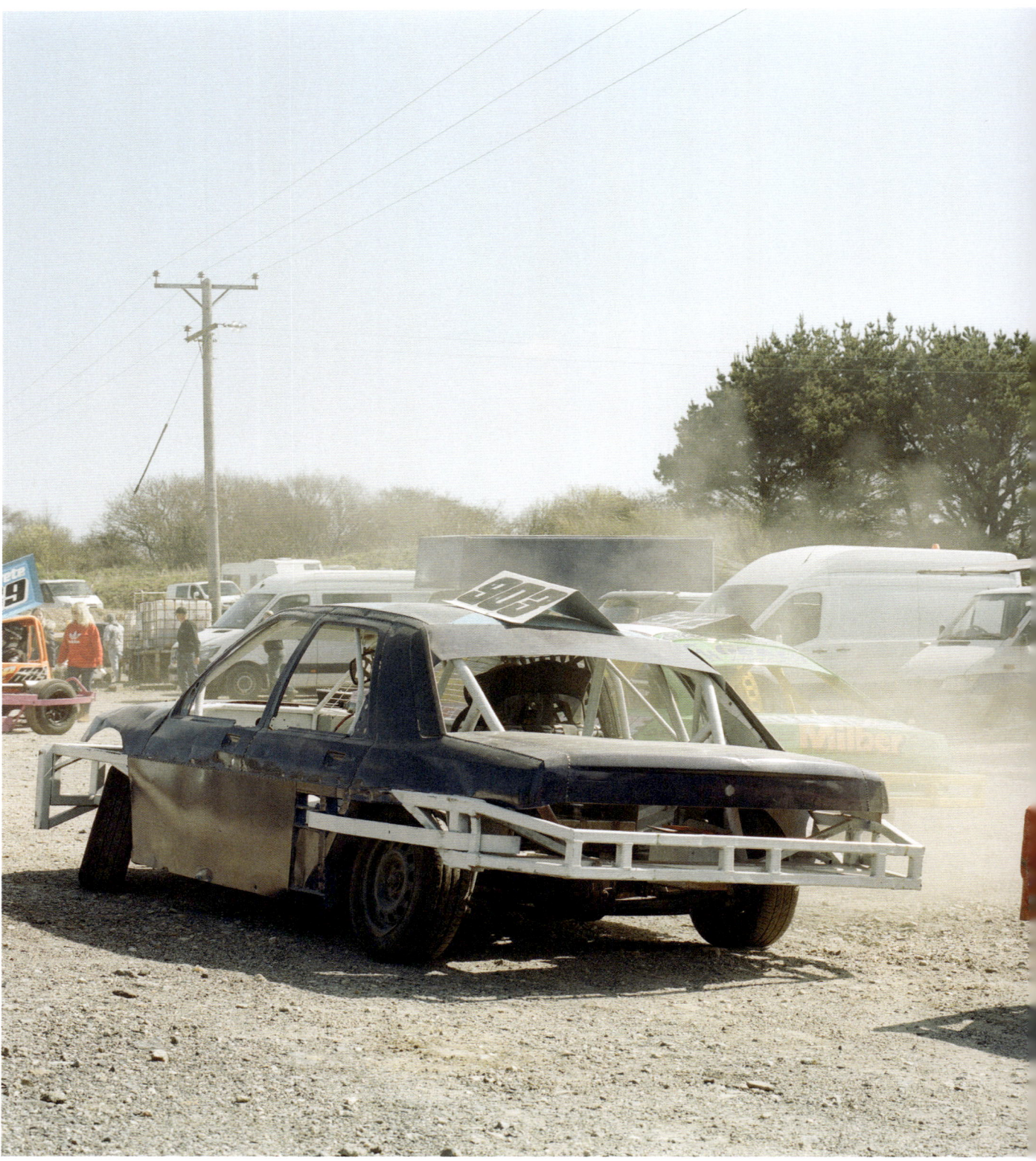

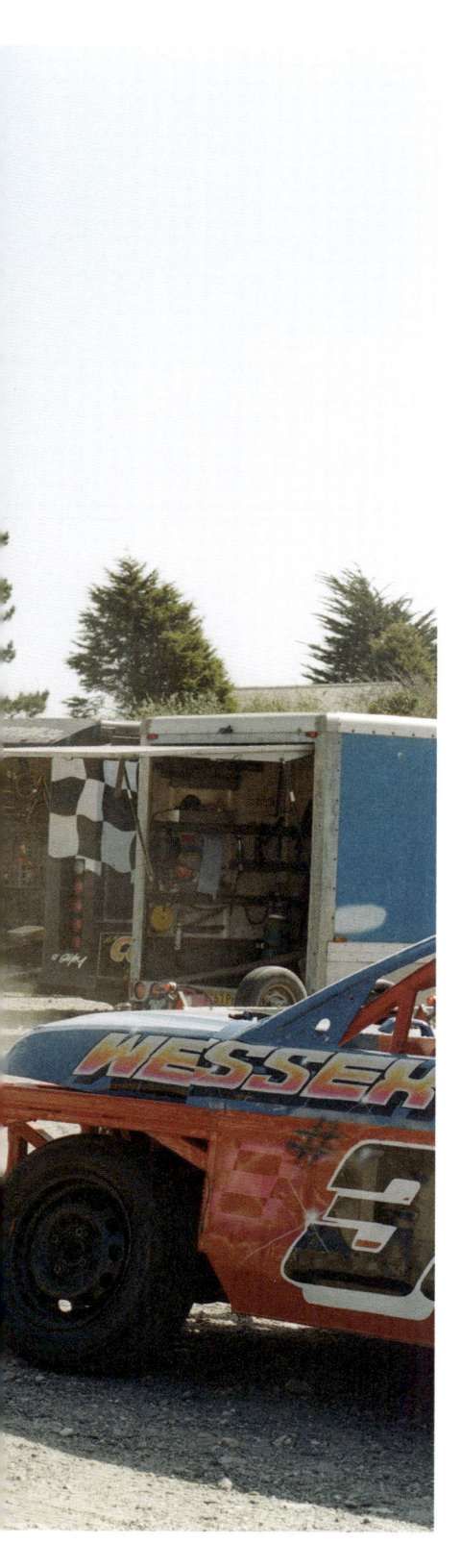

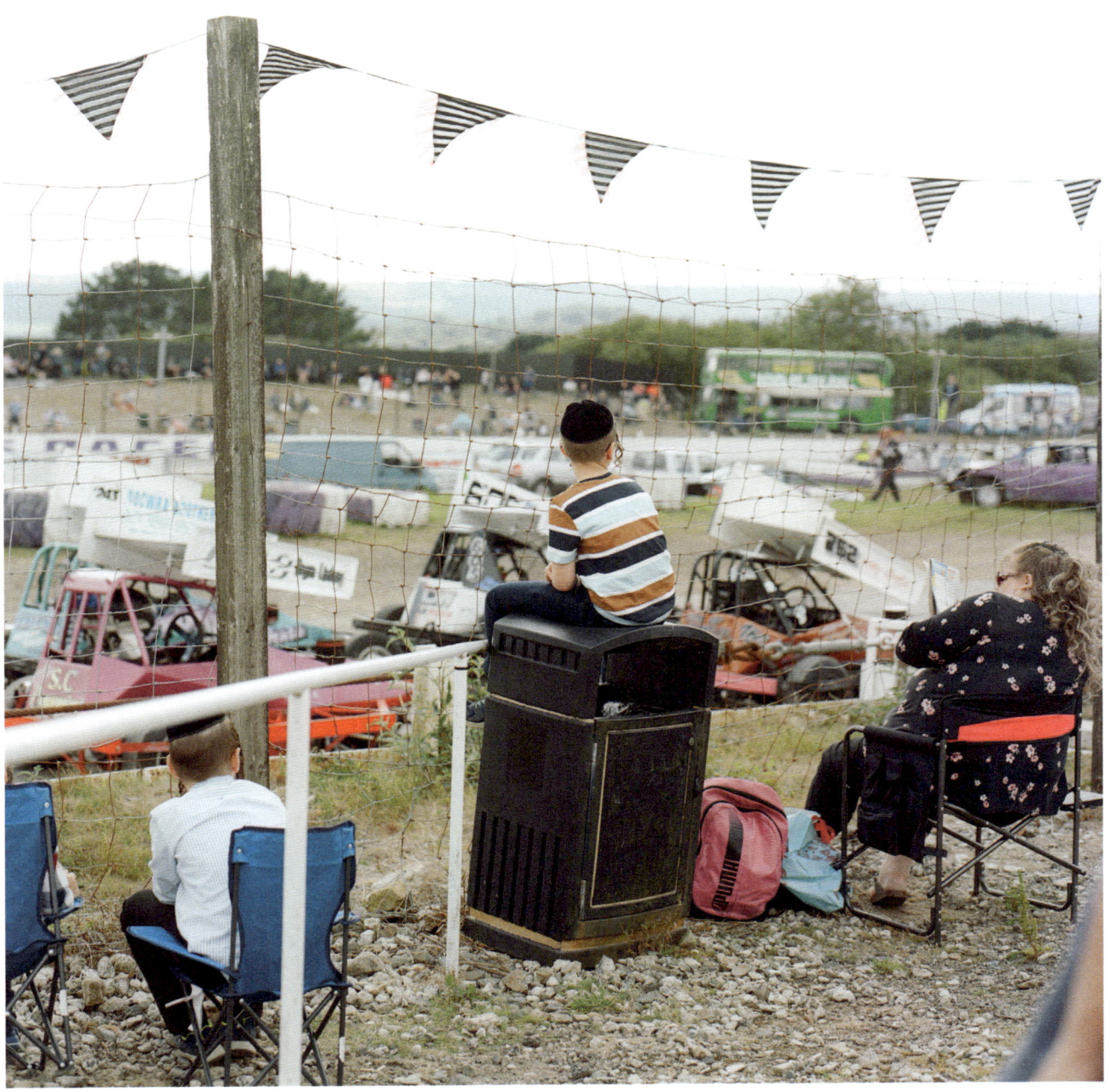

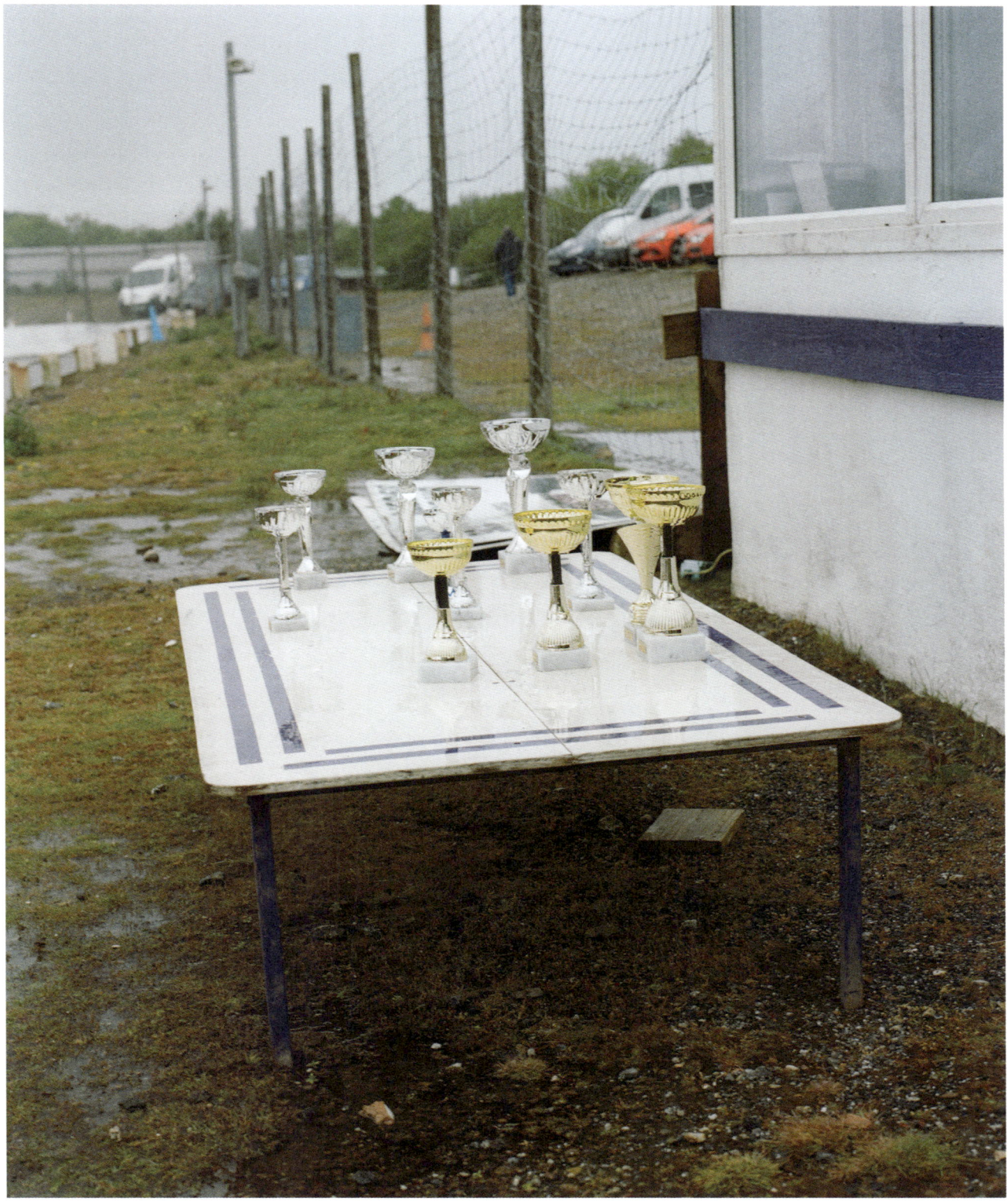

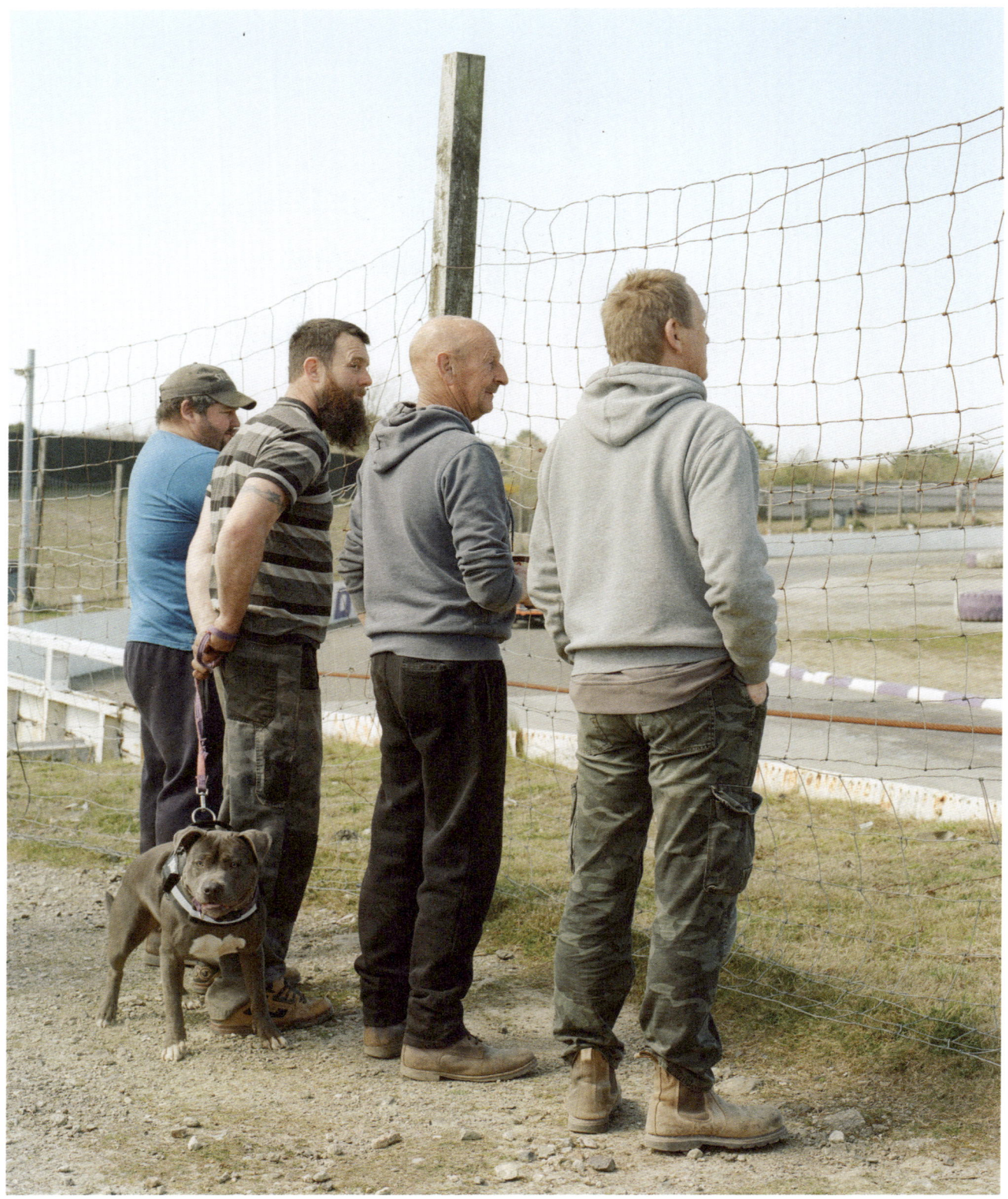

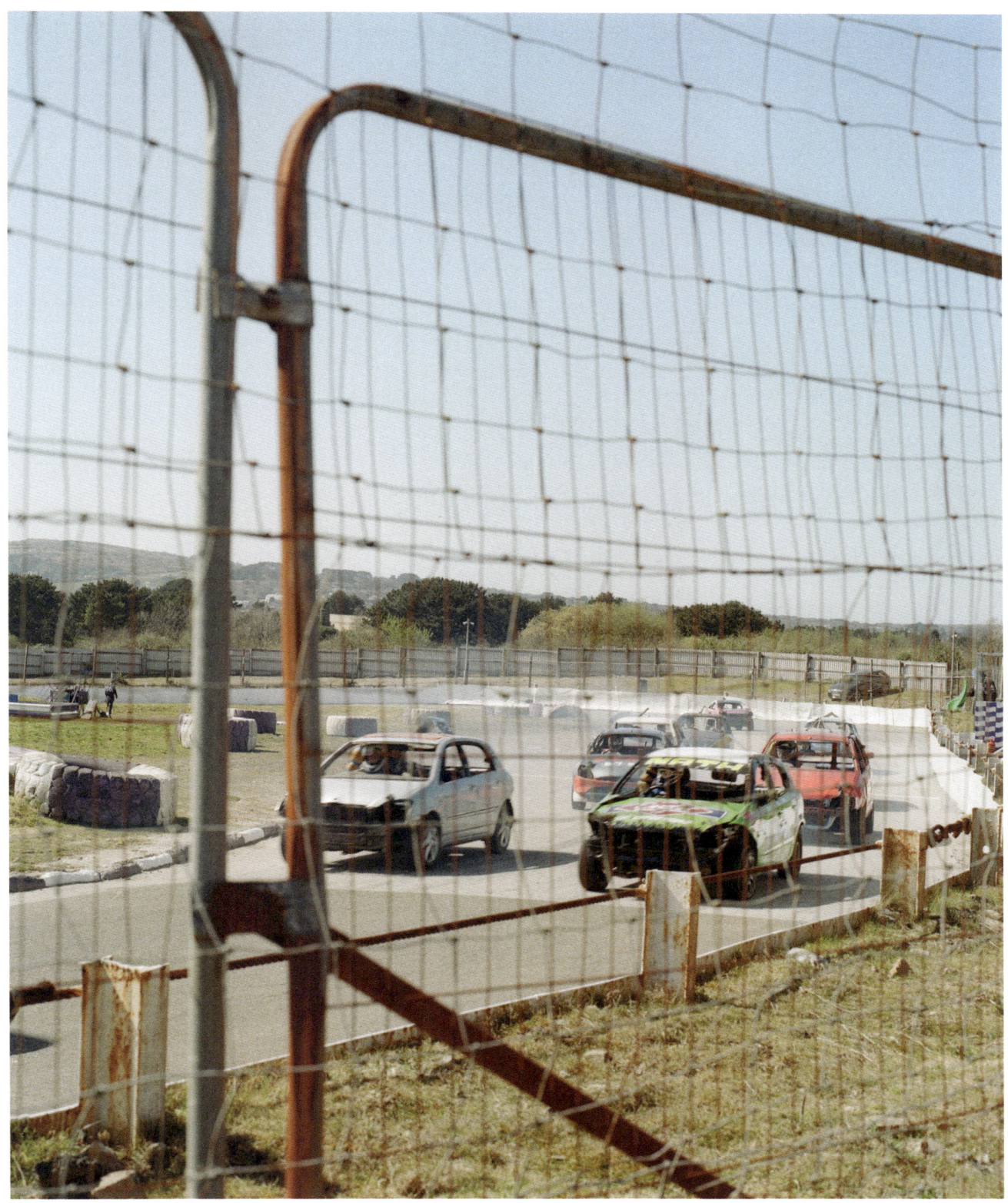

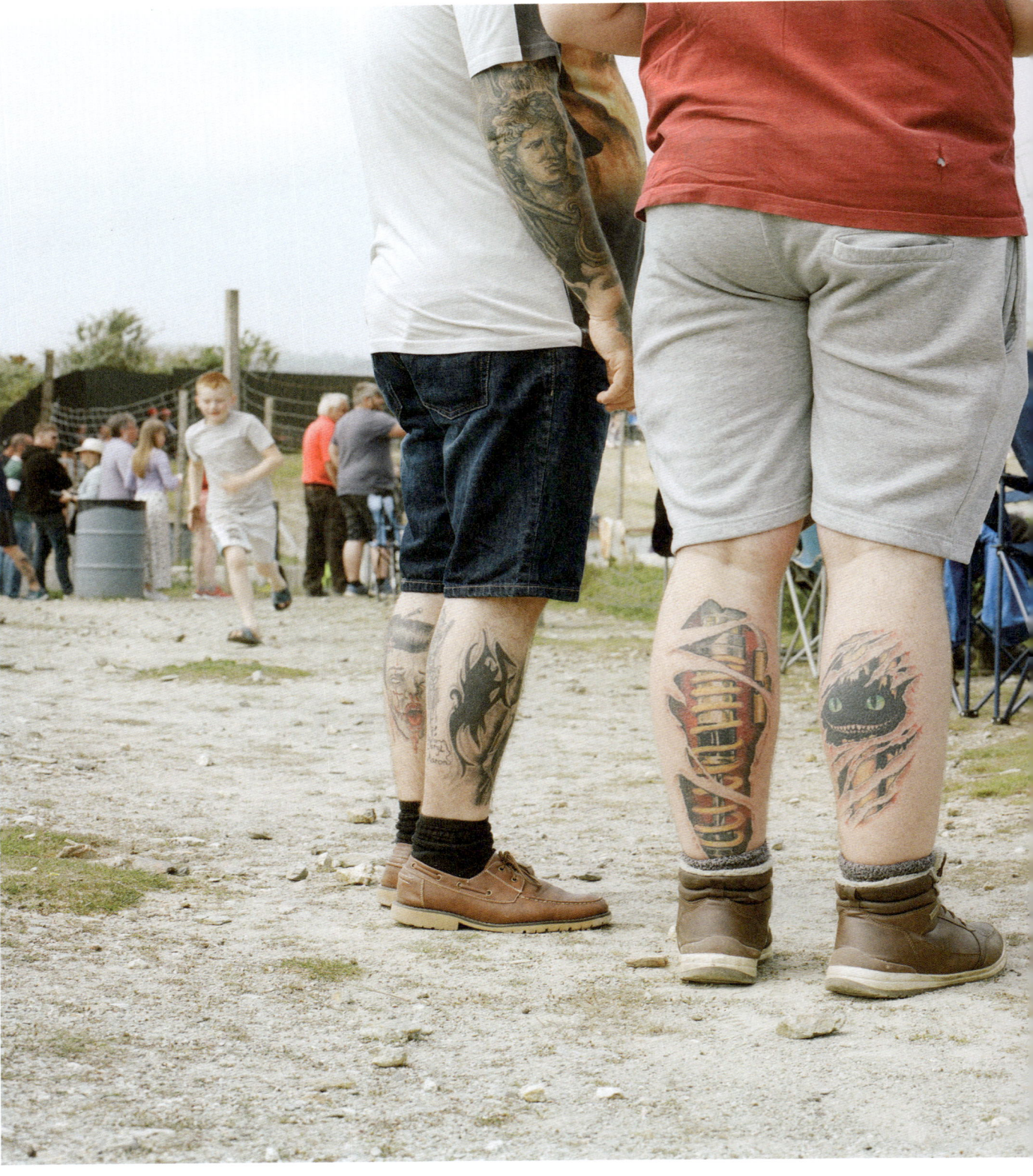

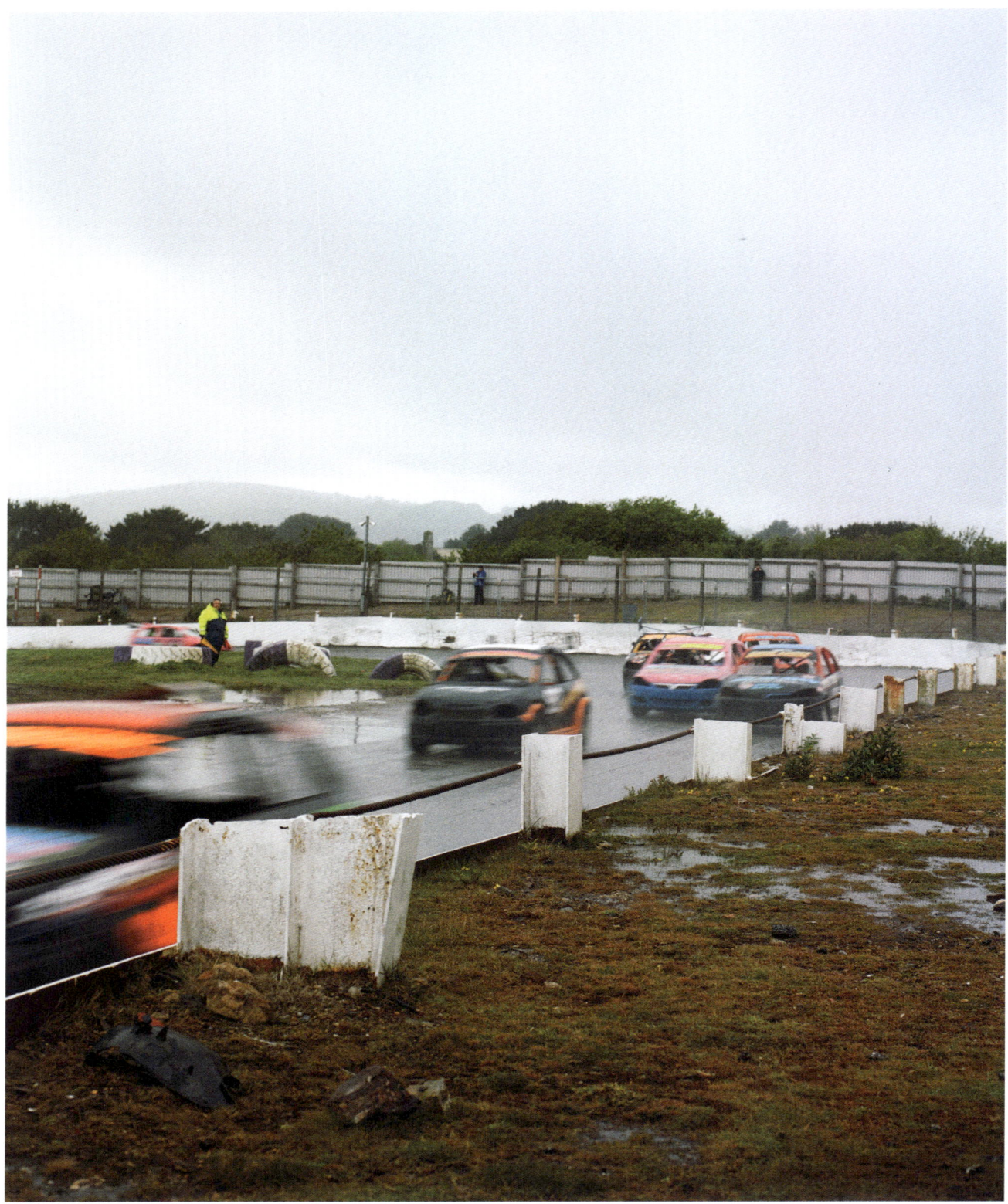

"SOME PEOPLE GO TO RACE...

OTHER PEOPLE GO TO CRASH."

REECE, BANGER RACER.

As we lived not far from the Cornish Stadium on Par Moor Road, my parents decided they would take me to a Tuesday evening Stock Car meeting, just to see how I responded. By all accounts I sat quietly, and obviously enjoyed it, because we went the next week and the next week and so on. I still have raceday programmes from 1971 onwards, and not soon after that time, my father's writing in the programmes was replaced by my own childish scrawls - writing down the race numbers of the cars of the starting grid, and then the results of the race. Fifty years later, I still do that.

In those early years, one driver caught my eye and became my favourite - 800 Roy Goodman. At the time, he was based in Lutterworth, near Rugby. To this small boy, it sounded an exotic place and yet, to this day, I have never been there. Looking back, I think there were three reasons why Roy stood out for me. Firstly, he was a regular winner; after all, he had been the very first World Champion in 1963. Secondly, his pink car was eye-catching, as there were very few pink cars. Thirdly, and I do think this was key, his race number - 800 - was the largest race number at that time. All the other drivers had numbers from 500 - 799.

I had an autograph book. It had pastel shades of paper, and every half a dozen pages, the colour changed, say from green, to blue, to pink, to yellow. I had a system that each time I filled up some pages and changed colour, that was my excuse to go and ask Roy for his autograph again. And again. I still have the book, and Roy's autograph is in there six times. No other driver is in there more than once.

In 1974, Roy opened a track of his own, at Smeatharpe Stadium, on the Devon-Somerset border, near Honiton. One day, in 1976, I asked Roy if I could sit in his car and have my photo taken. Roy was content for this to happen. As I got in, I could hardly have been more excited. I grabbed hold of the steering wheel and my father took the picture. As I got out, the first thing I told my mother was, "It's really dirty in the car!" If ever there was a moment to note I would be an office boy…

CRISPEN ROSEVEAR

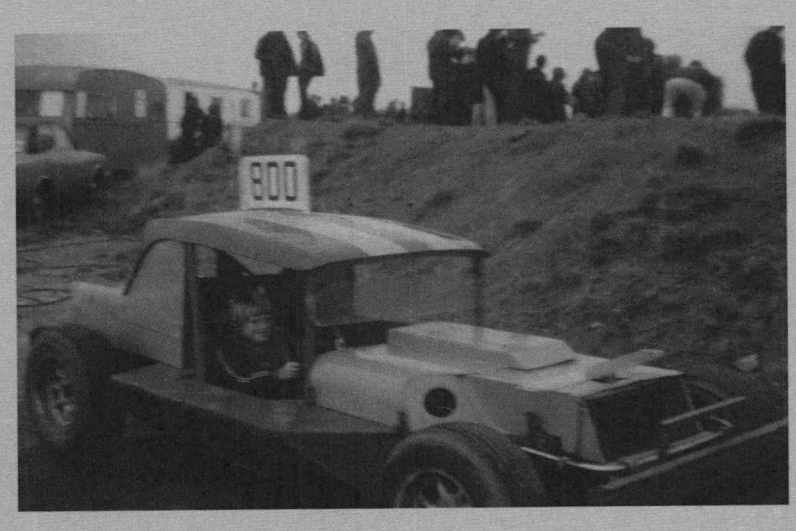

CRISPEN AS A CHILD, 1976.

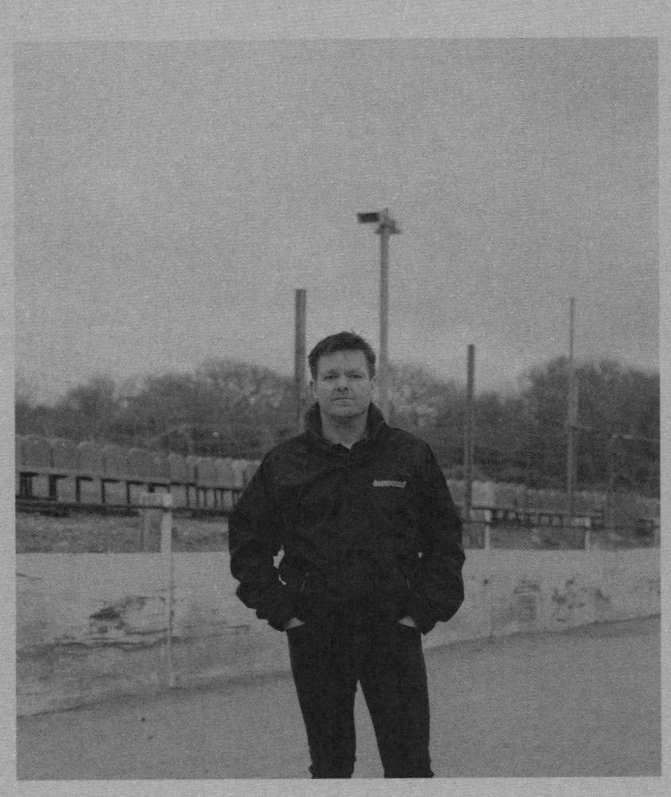

CRISPEN TODAY, 20 YEARS INTO HIS CAREER RUNNING UNITED DOWNS RACEWAY.

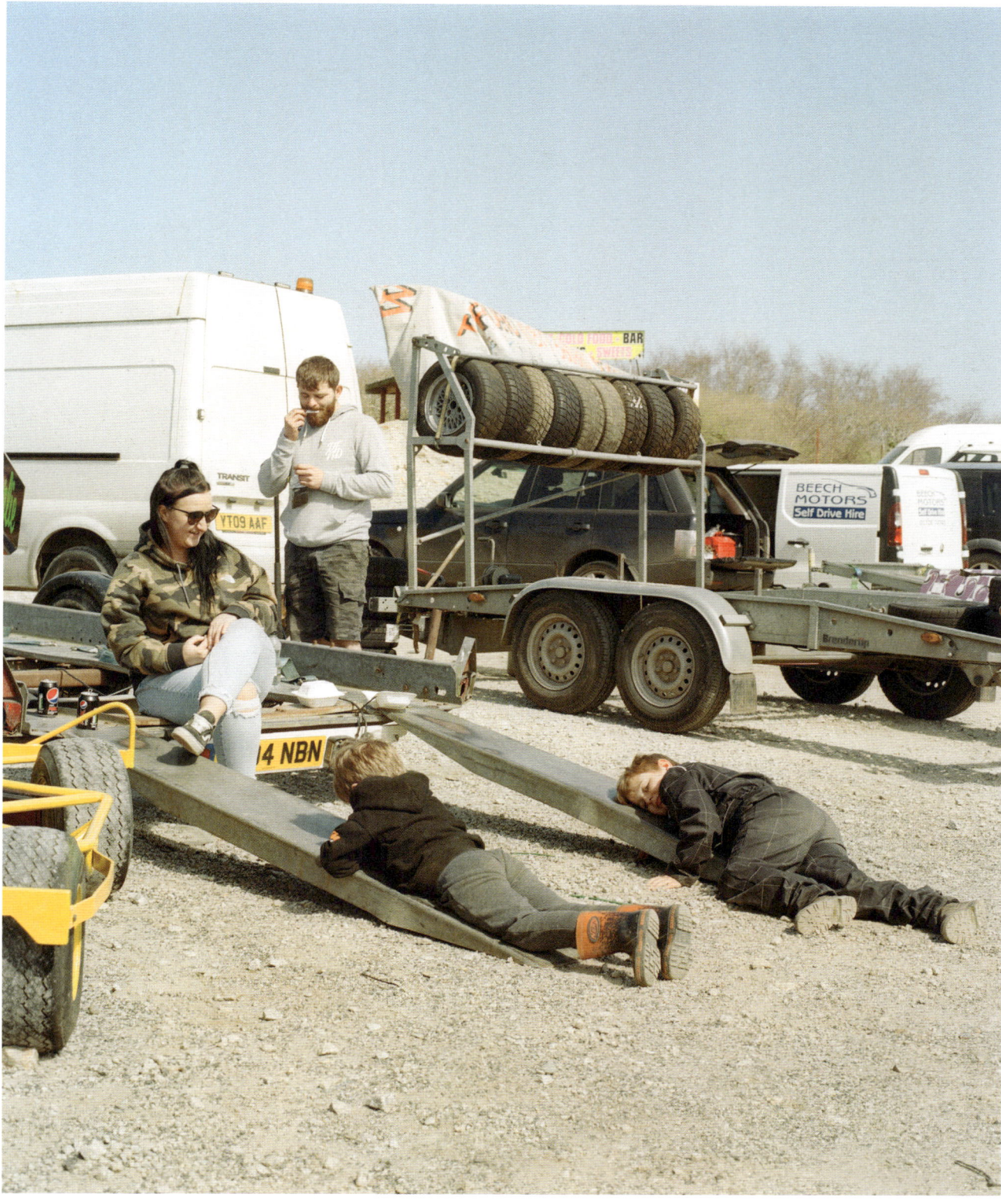

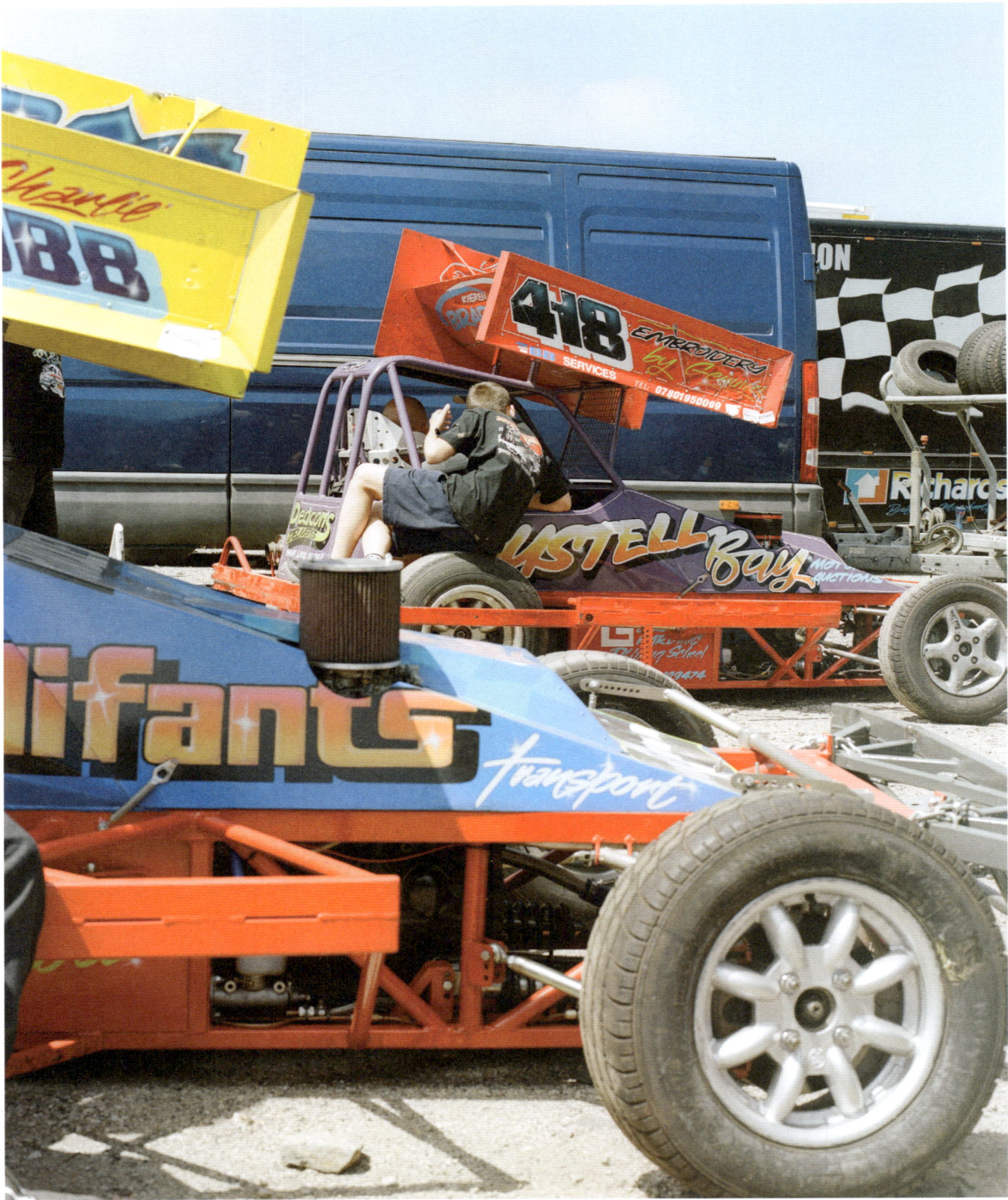

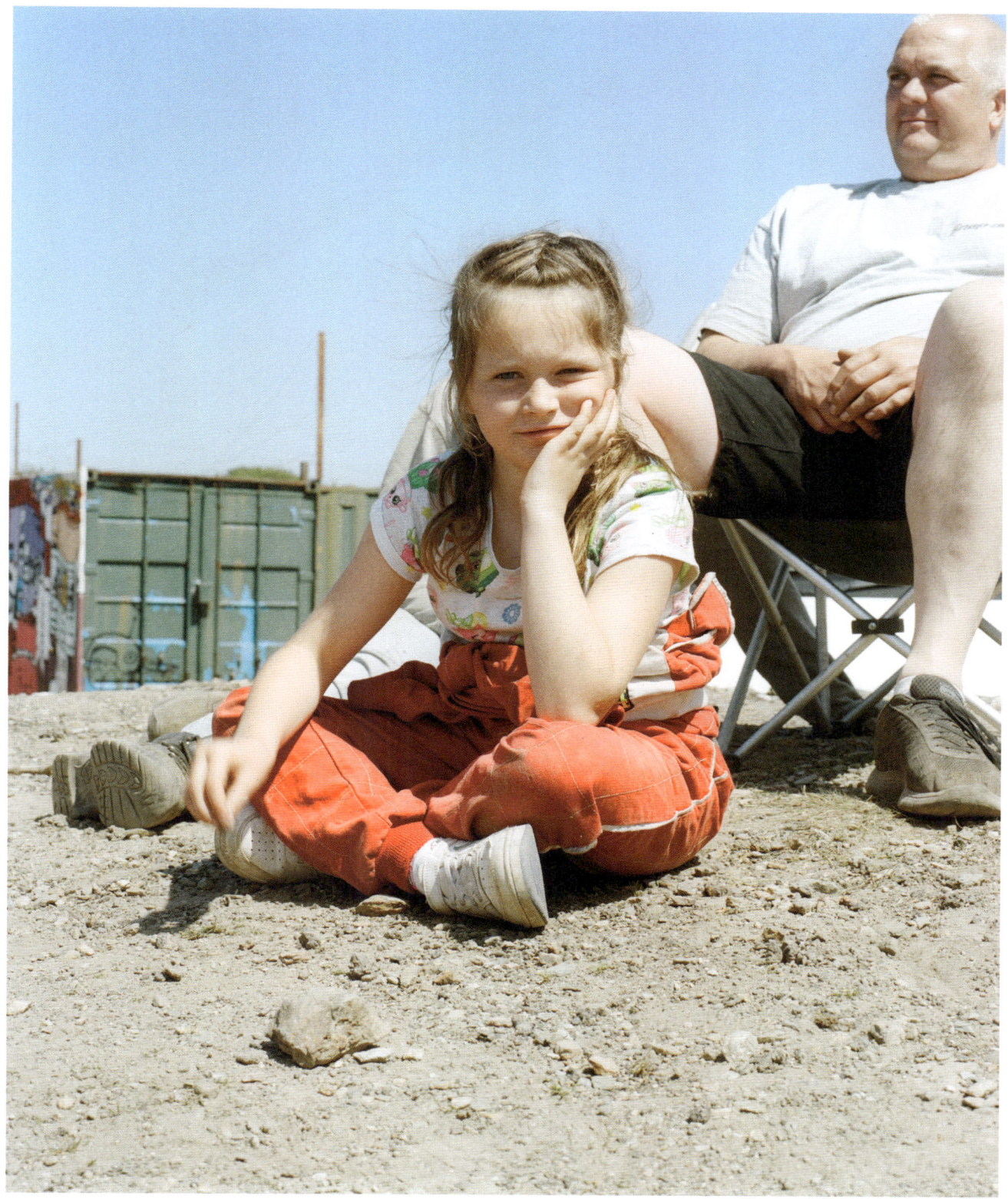

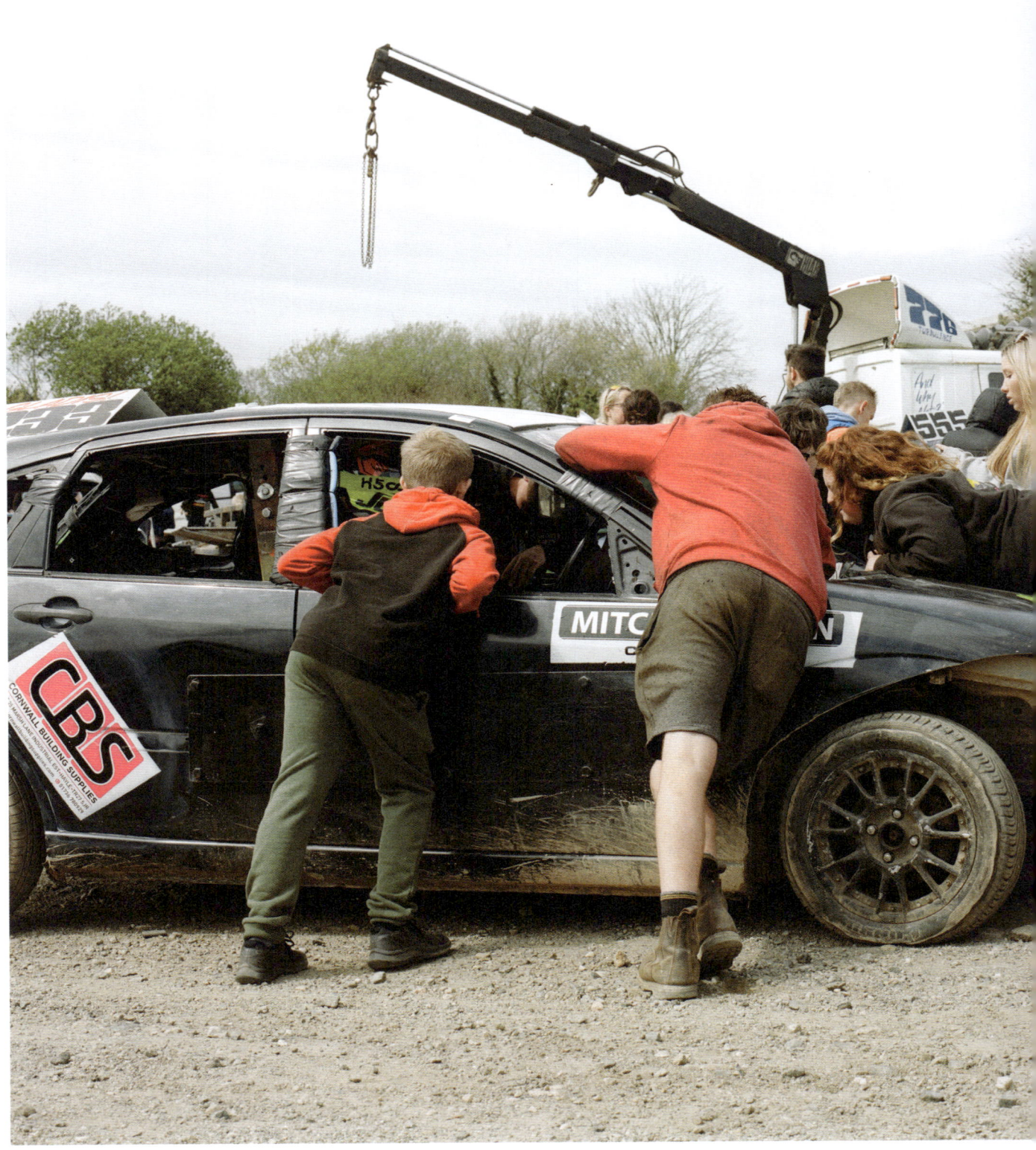

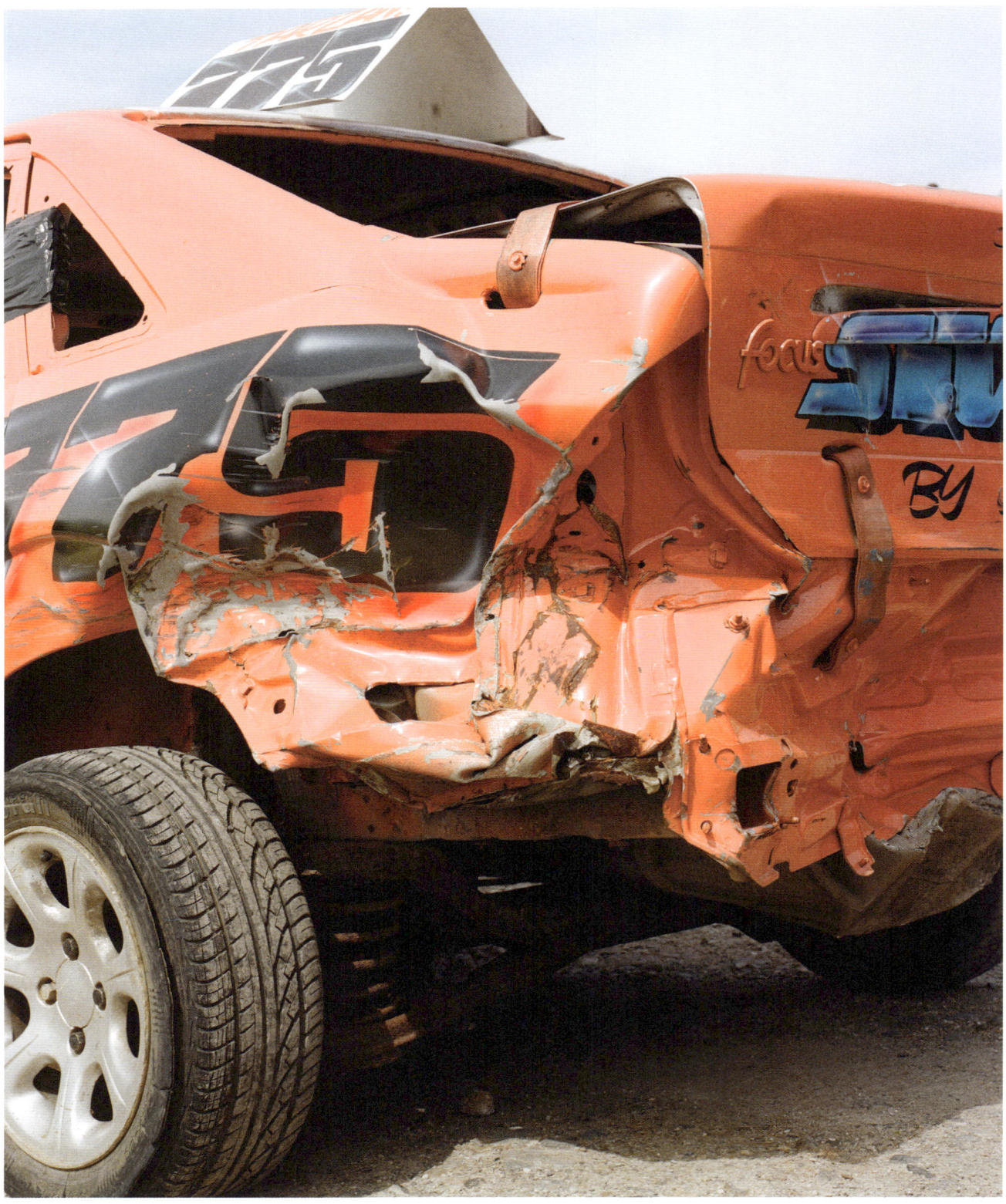

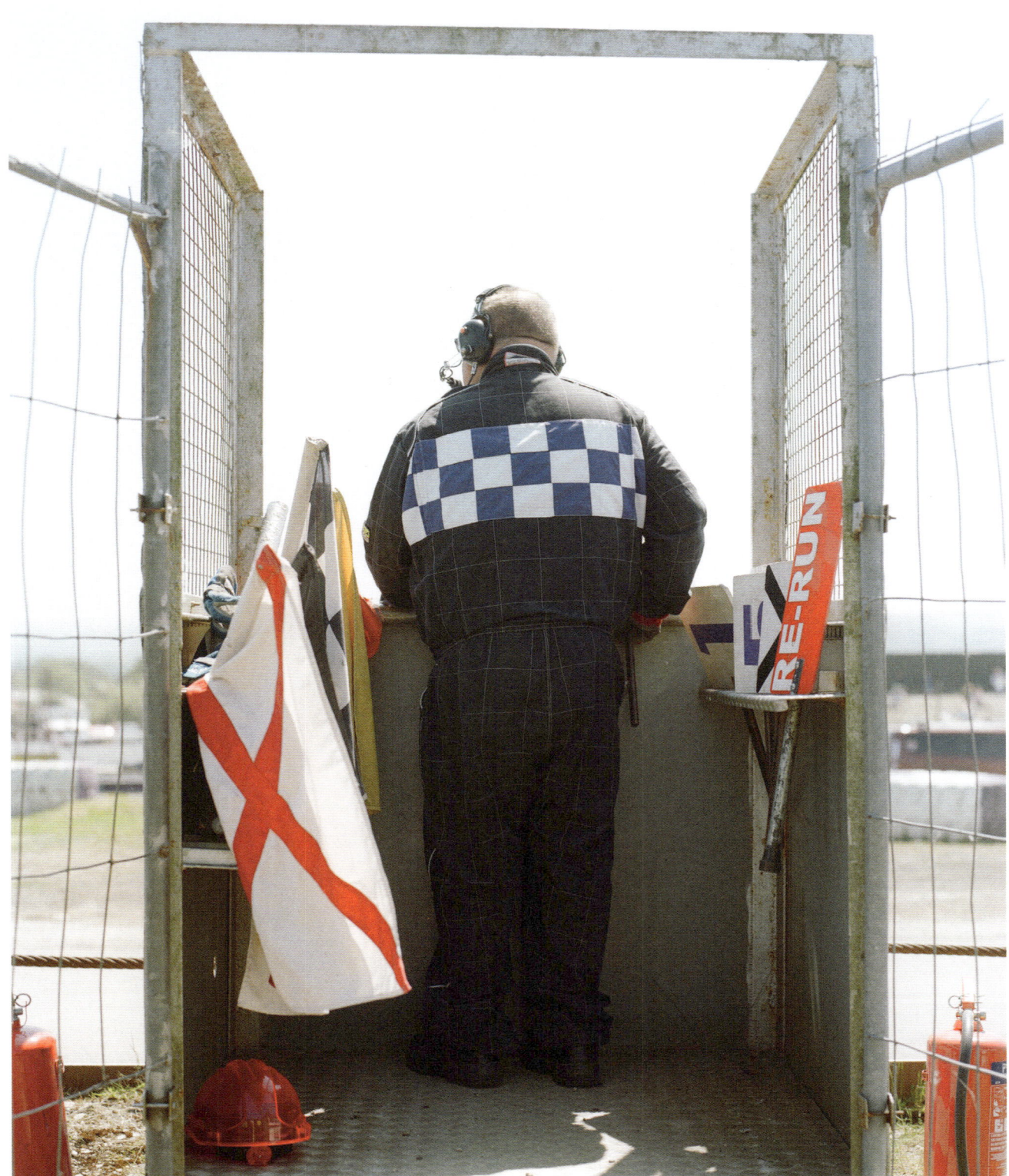

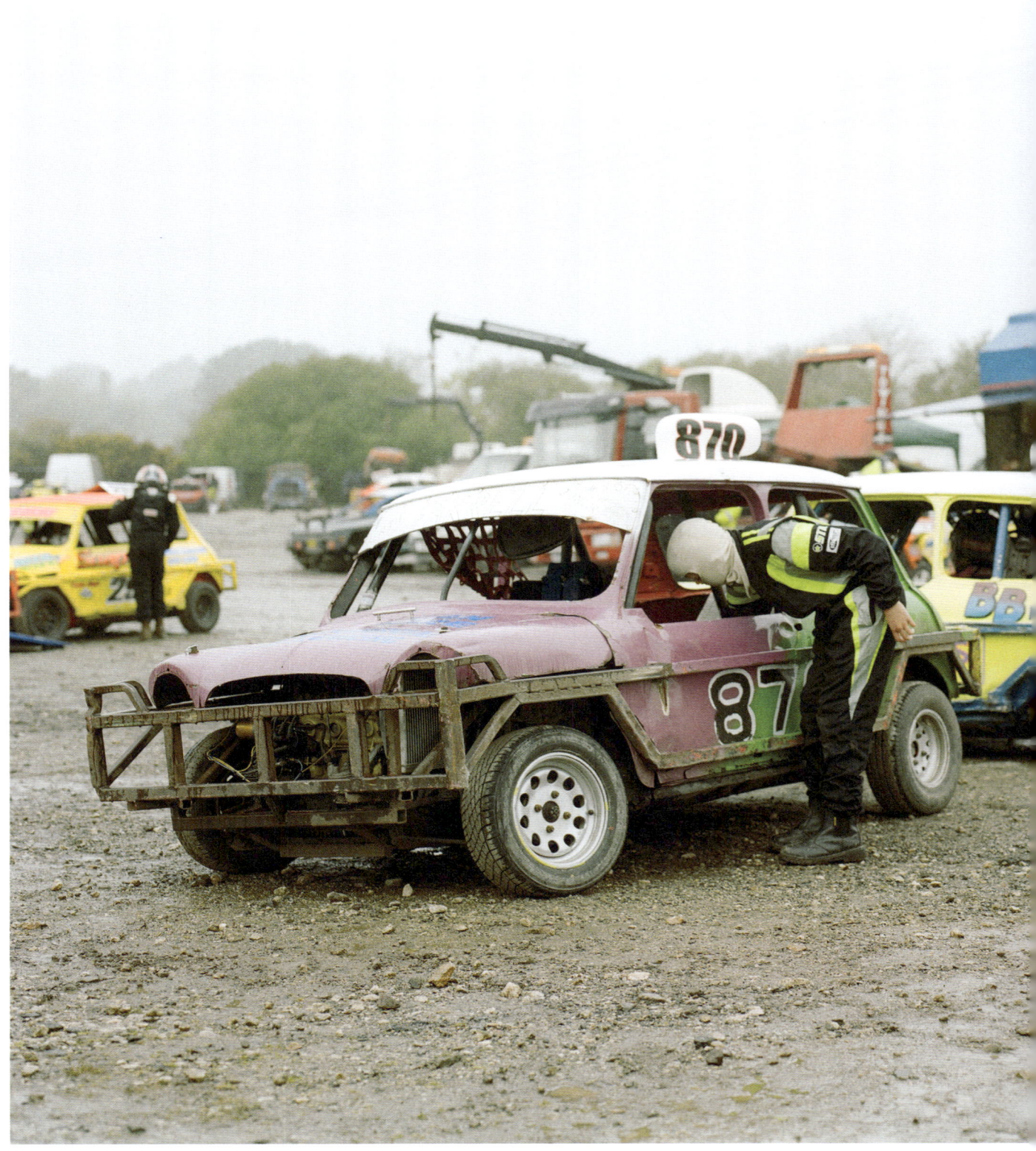

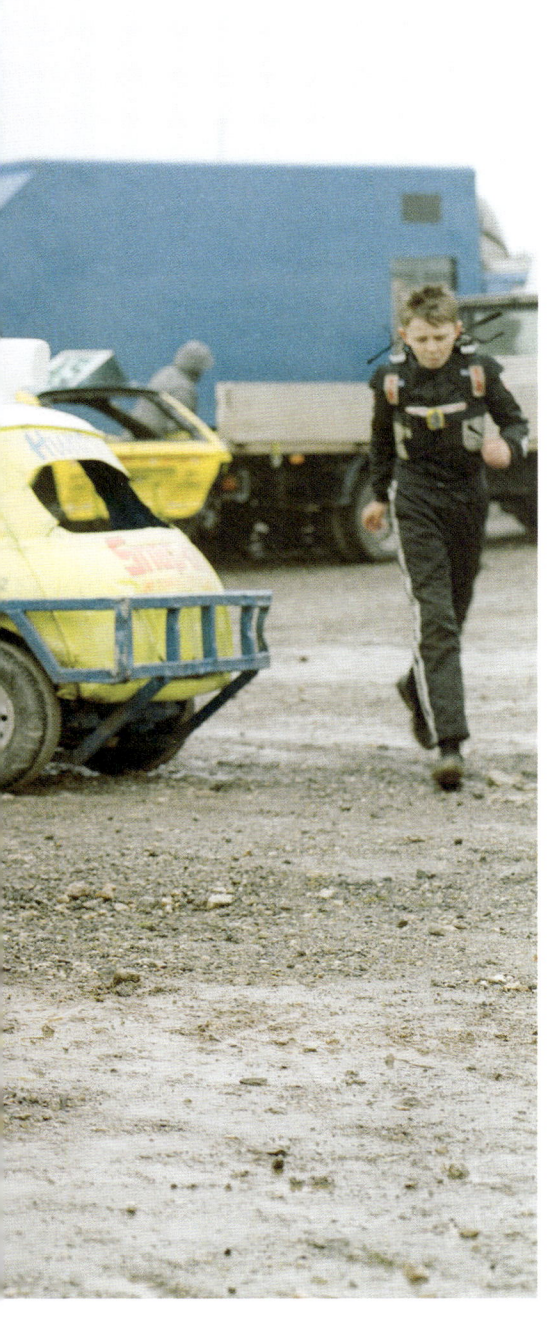

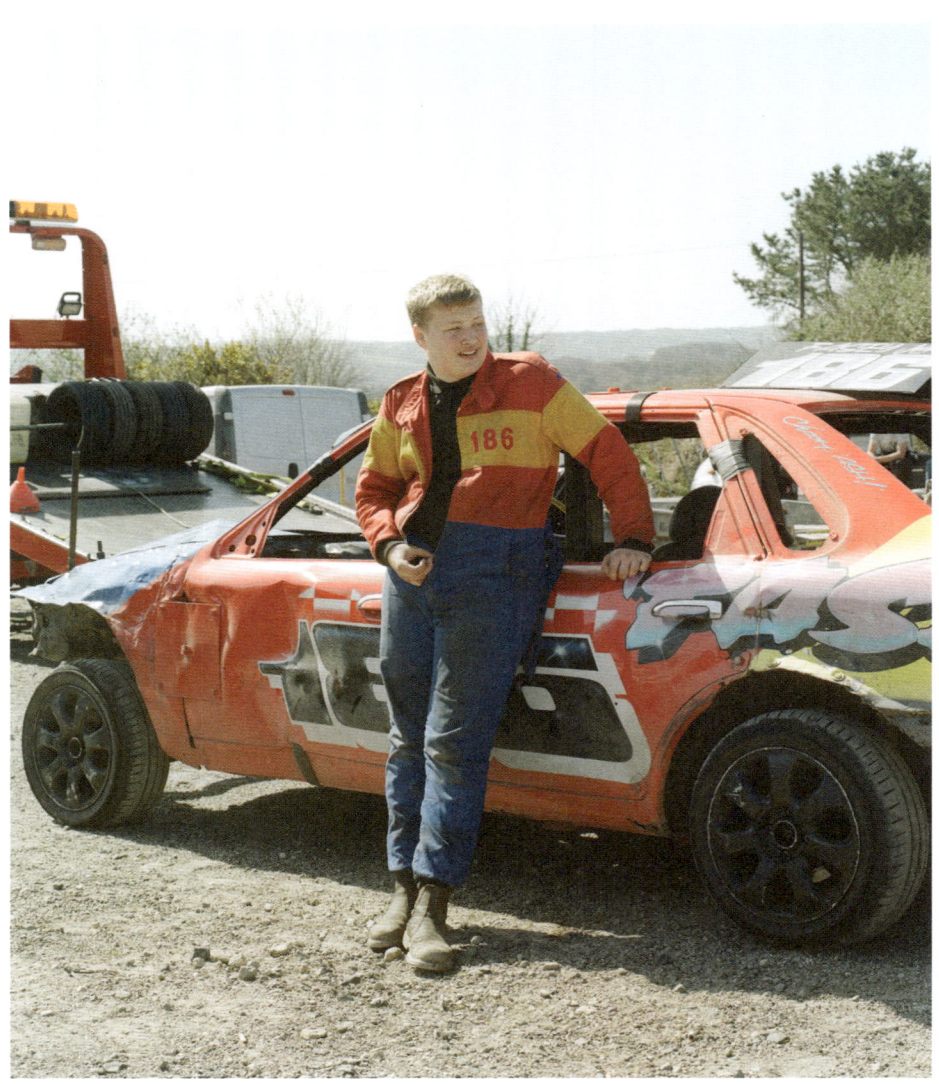

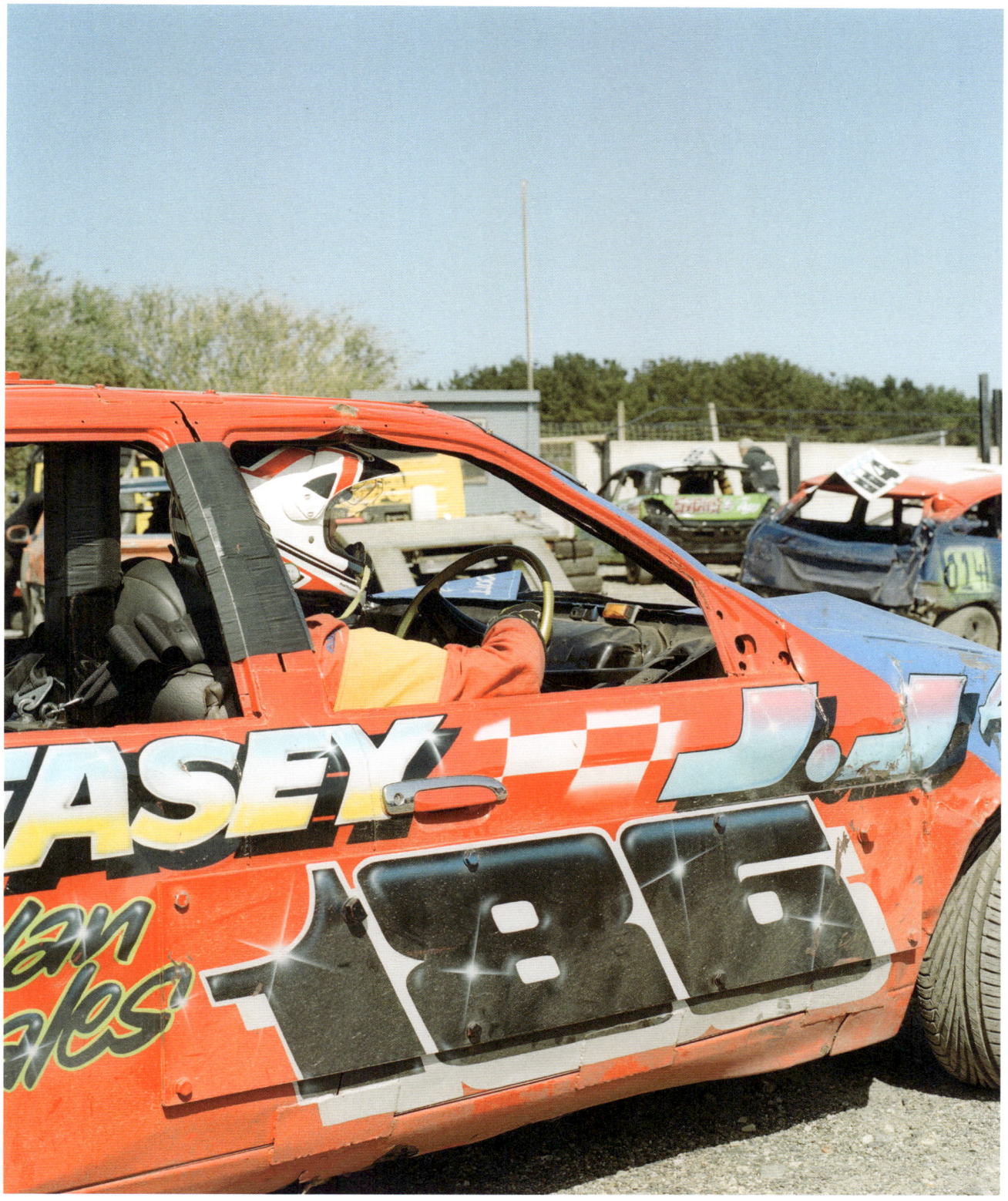

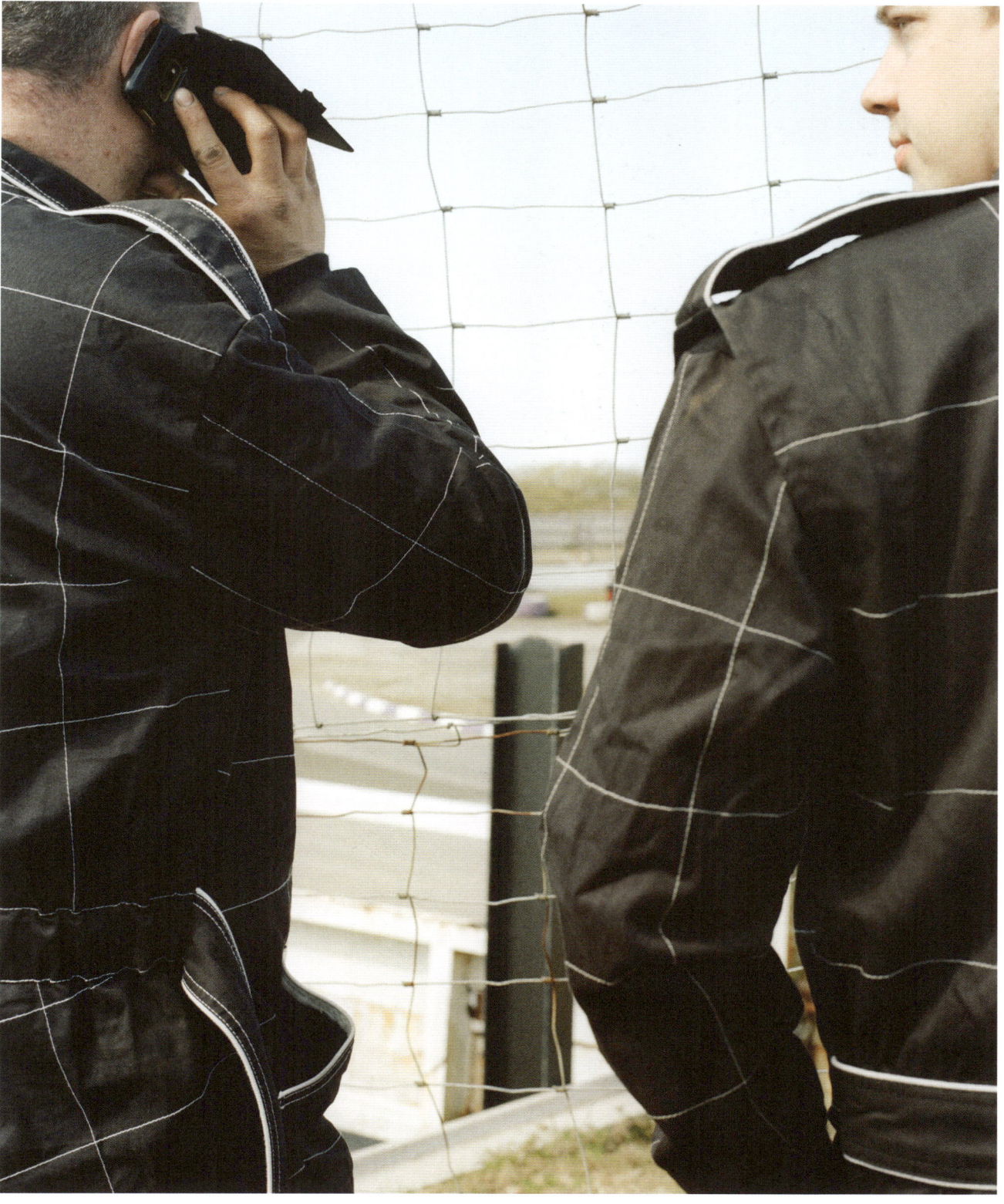

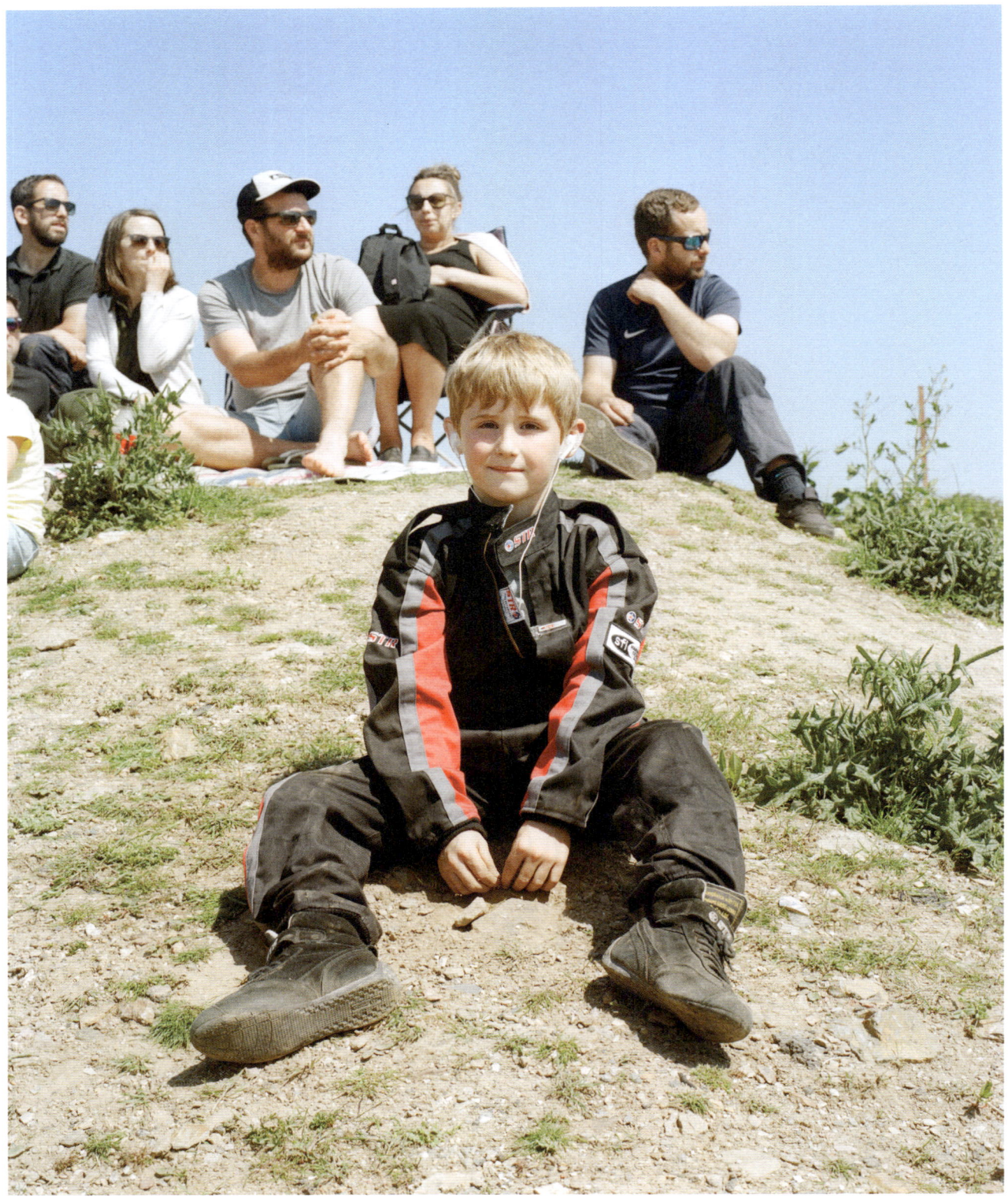

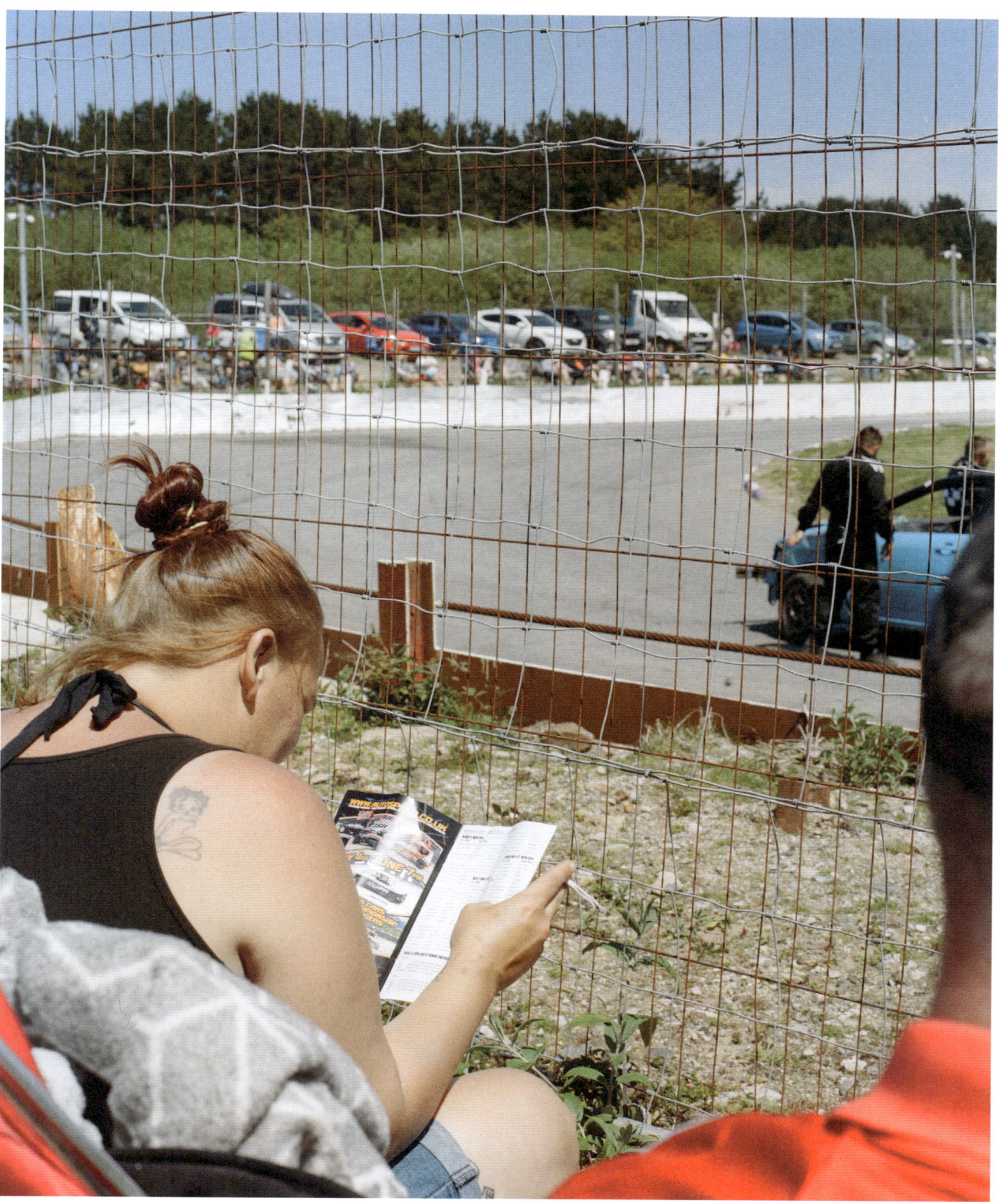

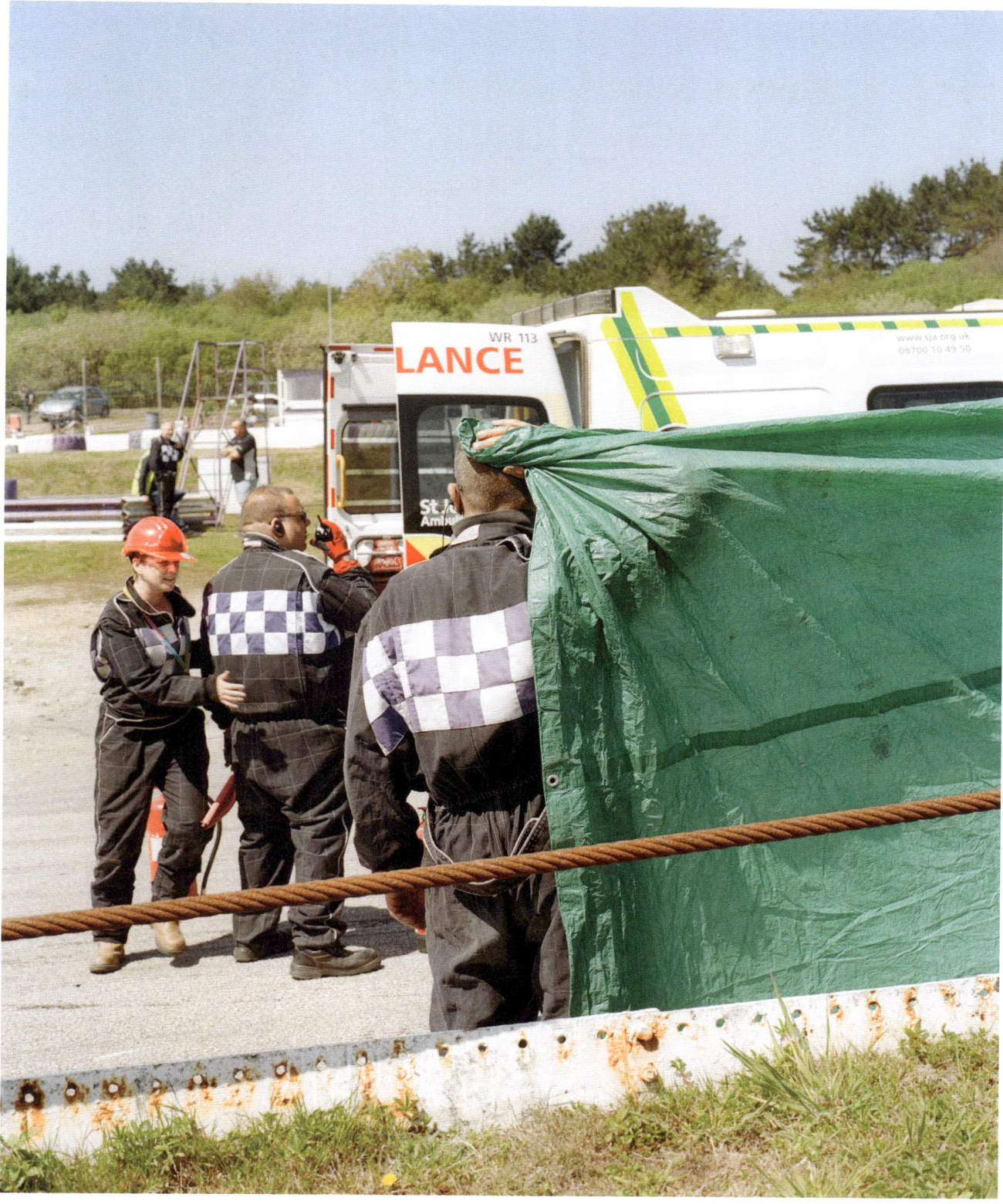

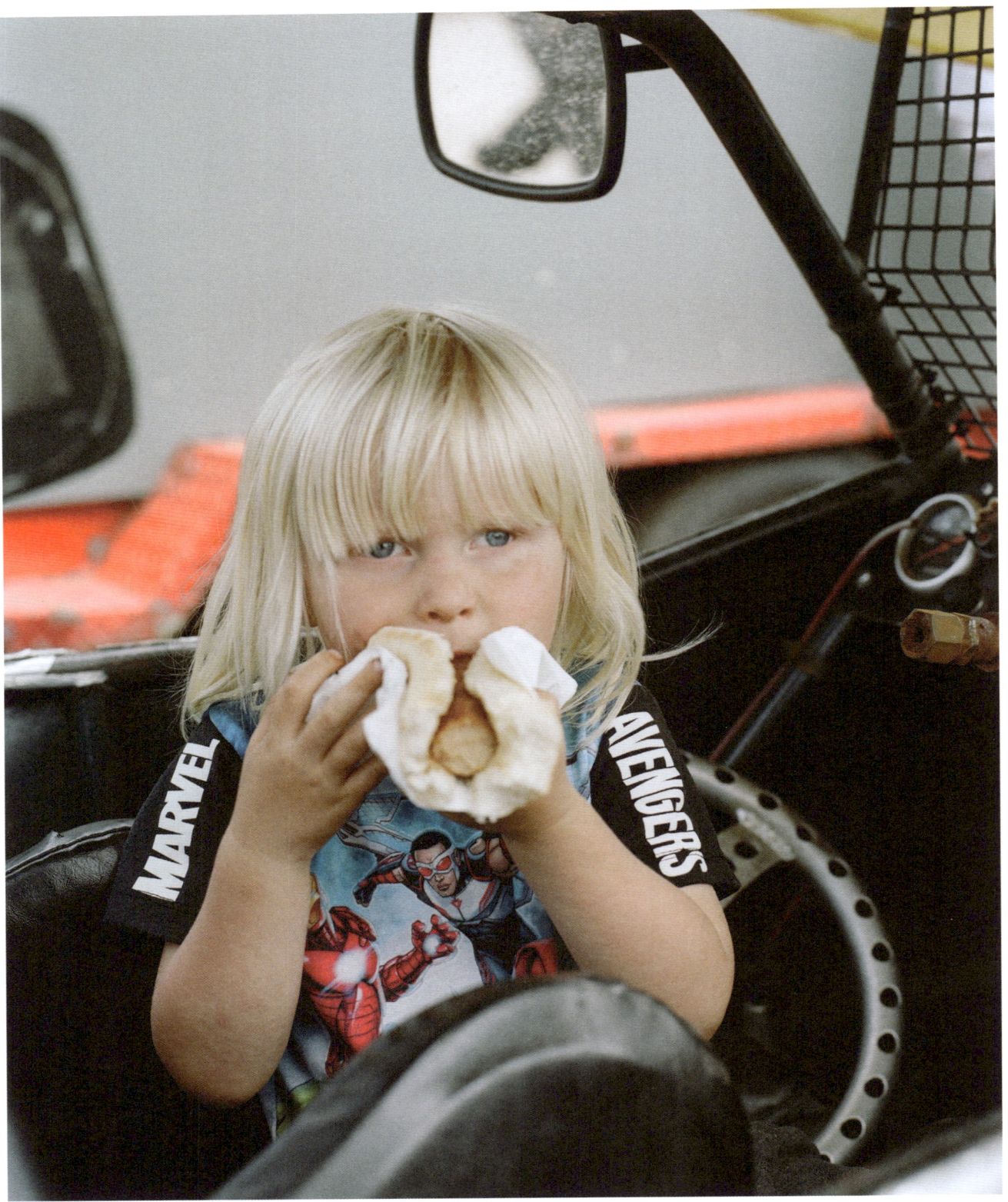

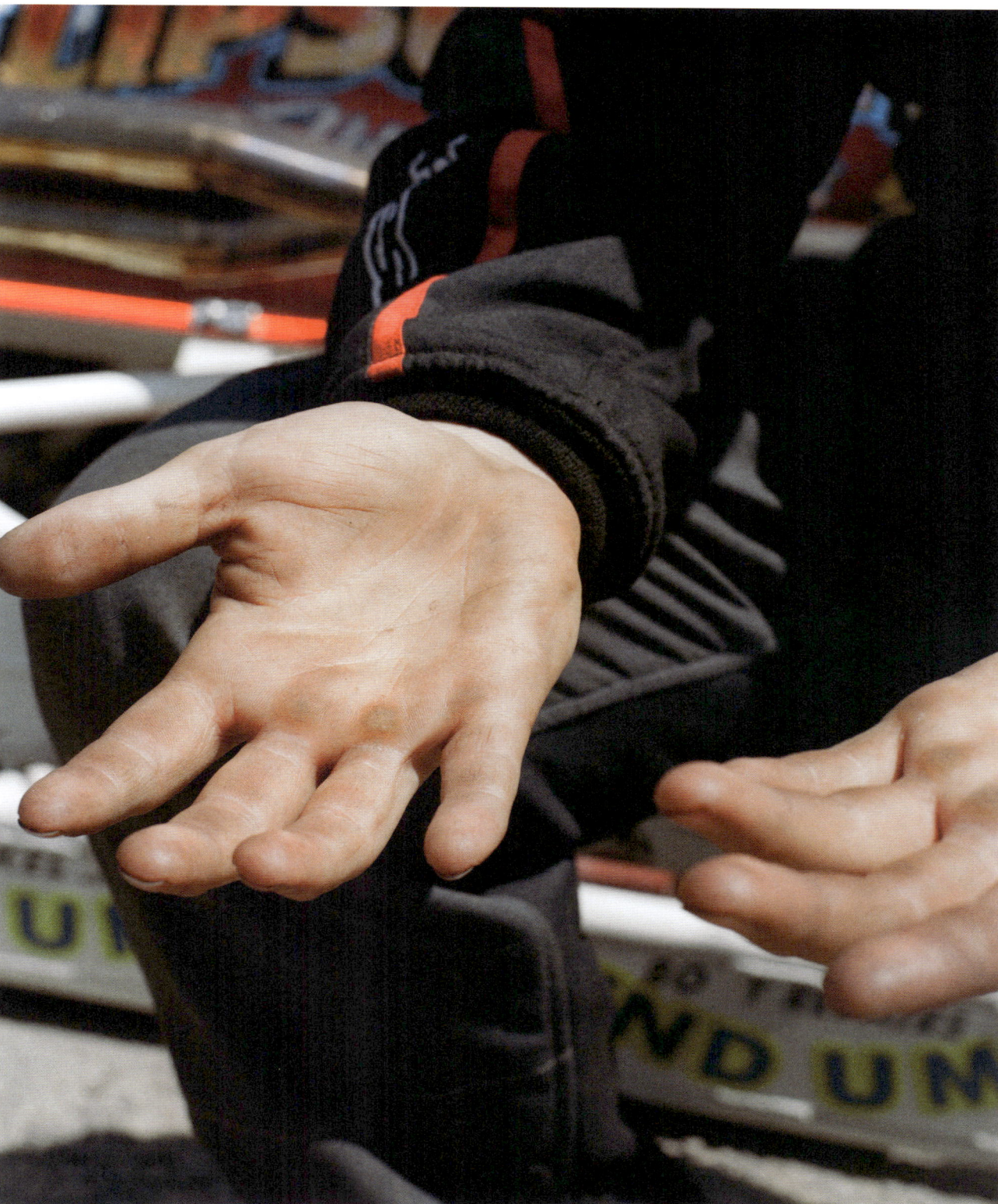

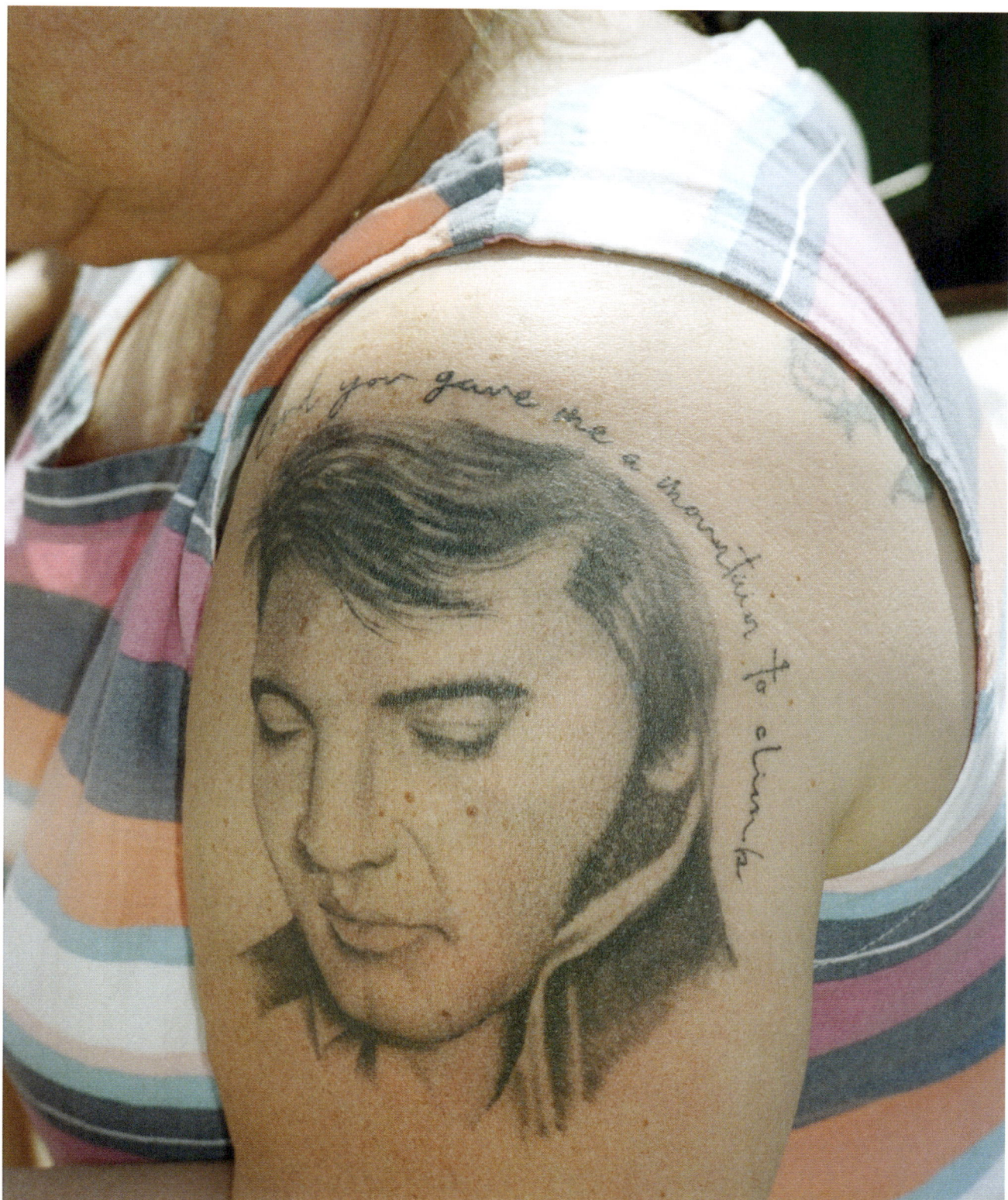

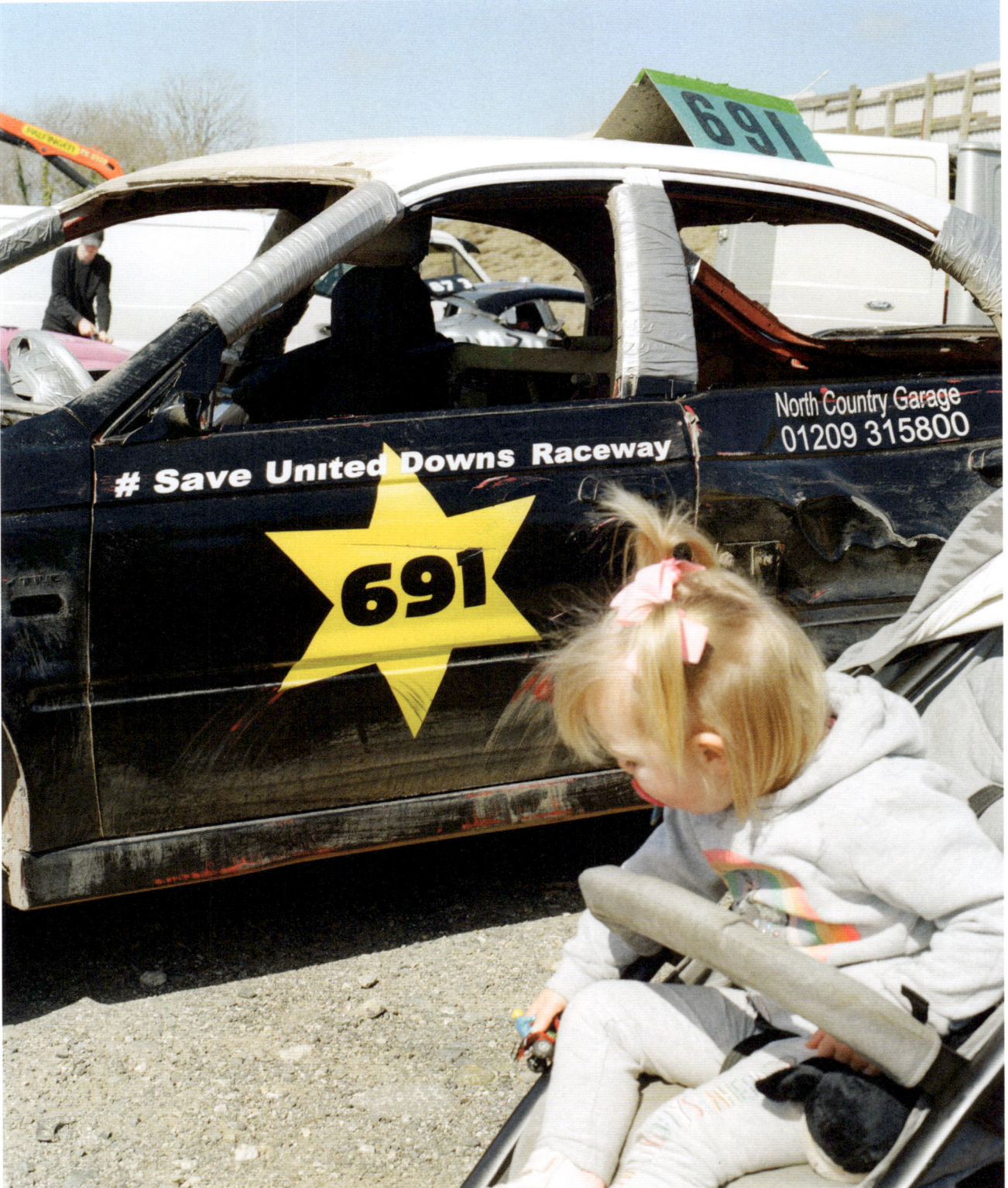

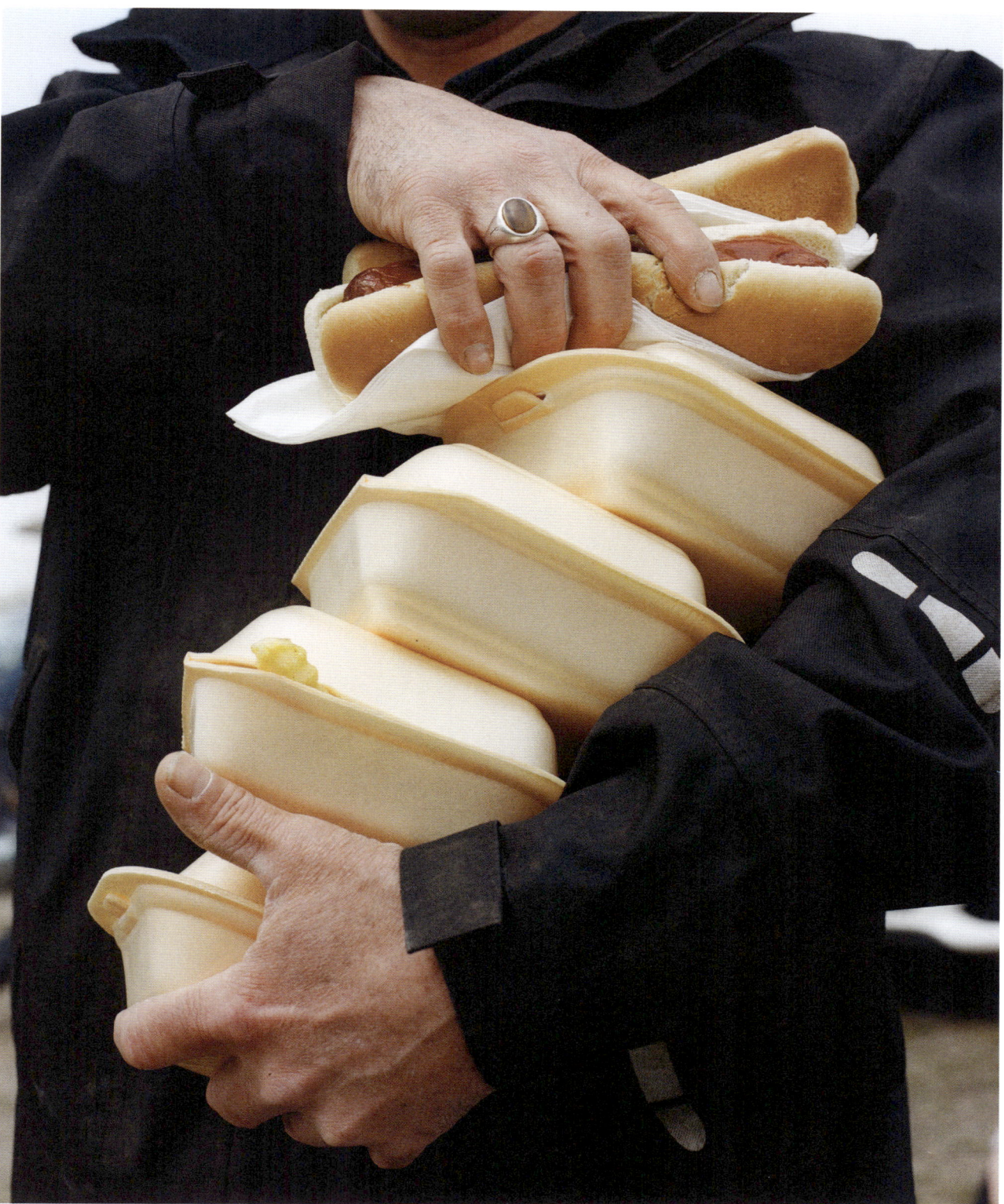

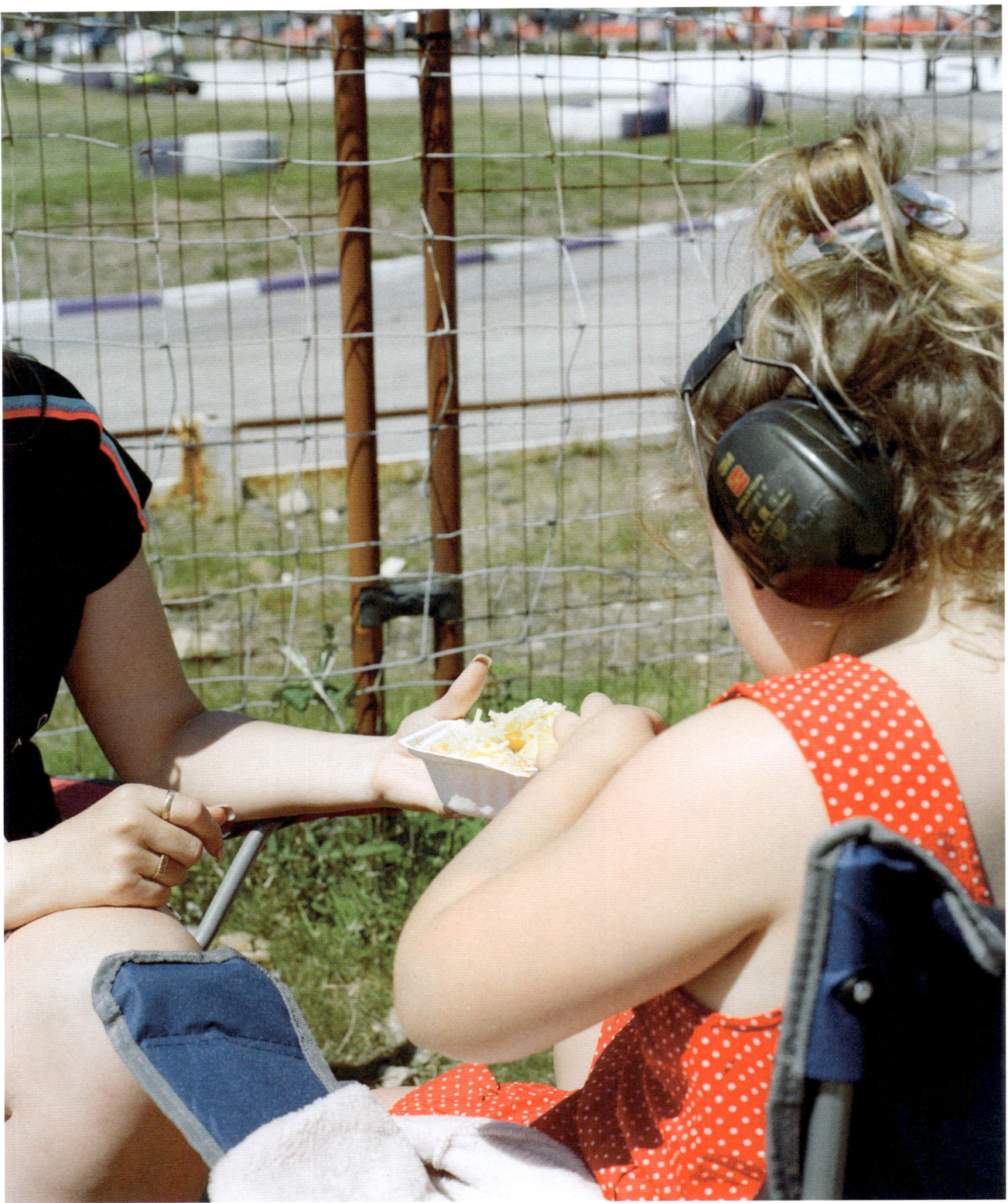

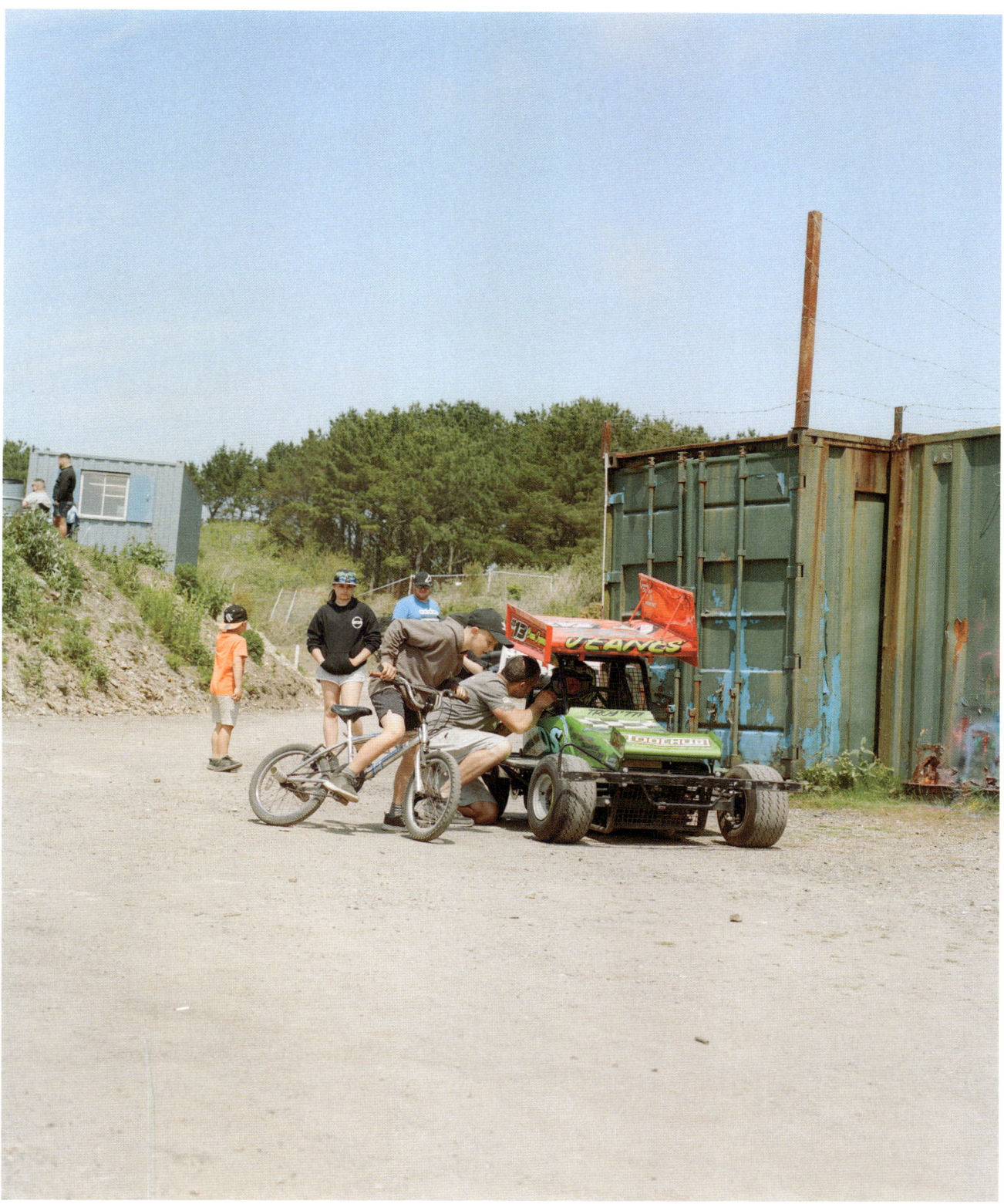

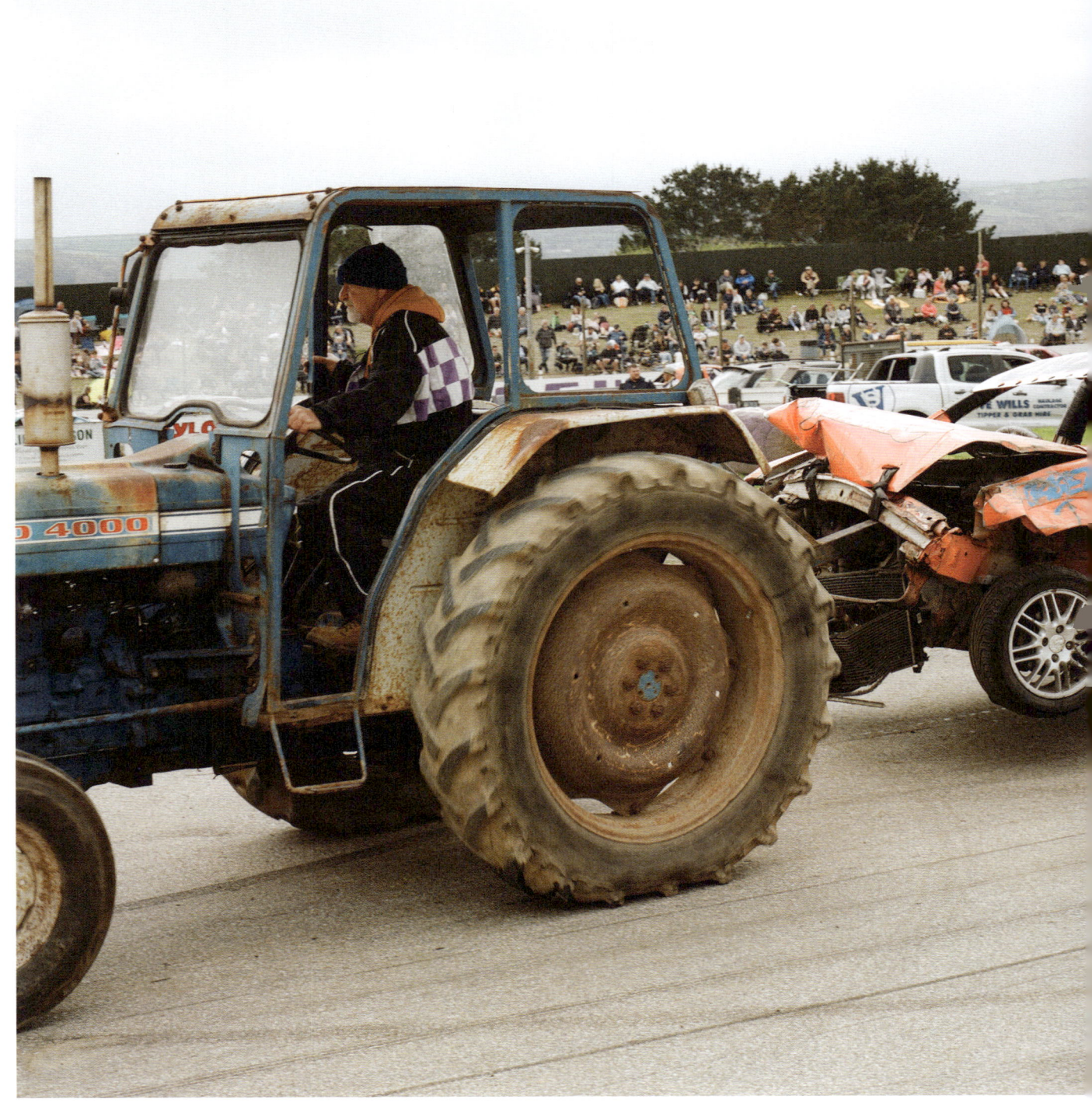

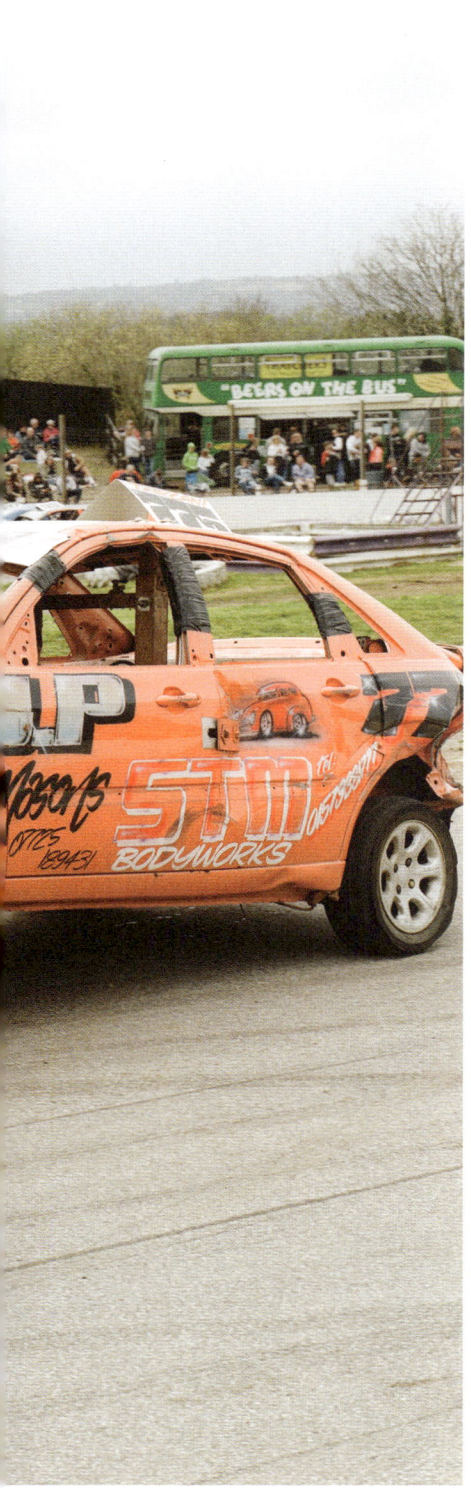

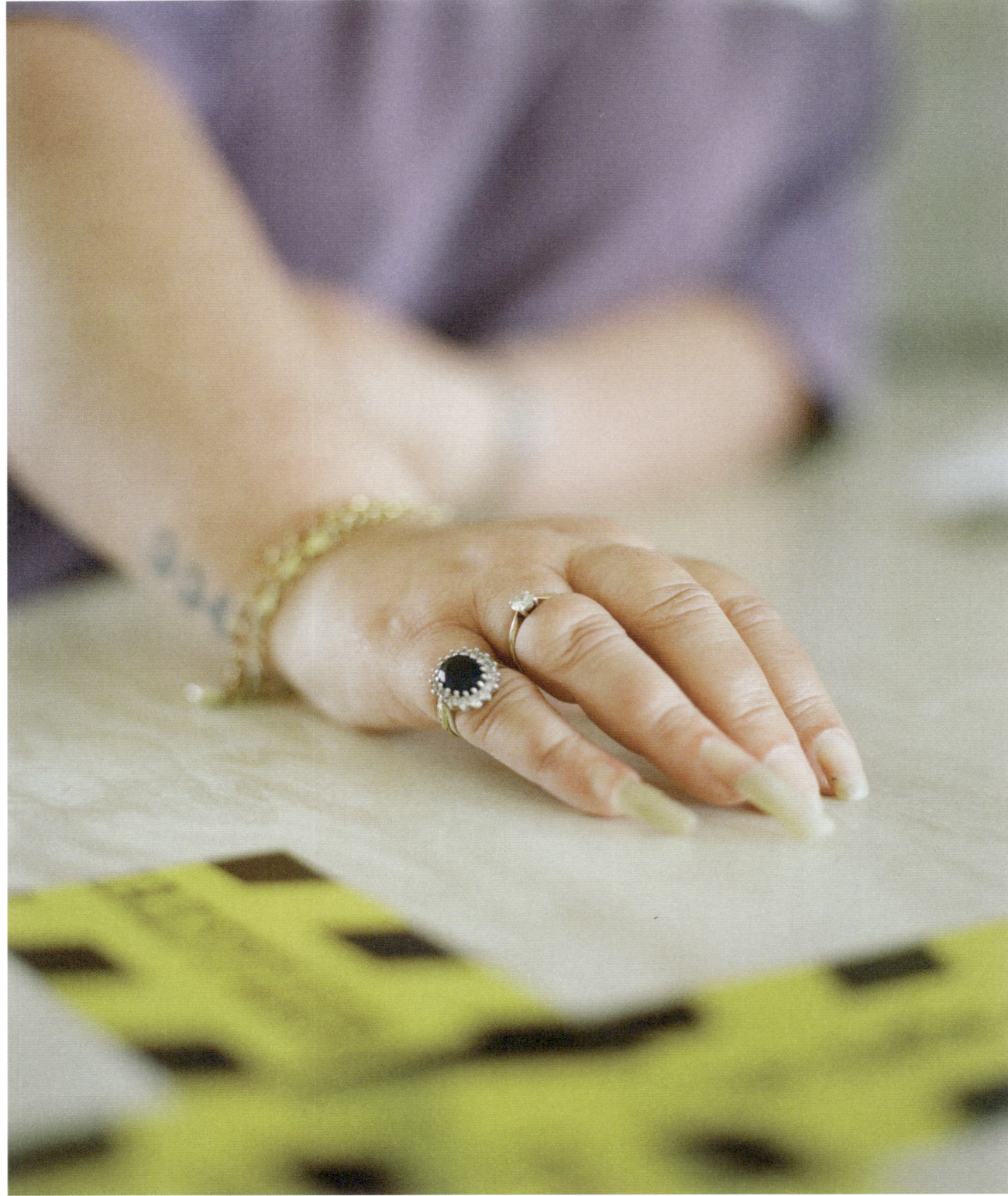

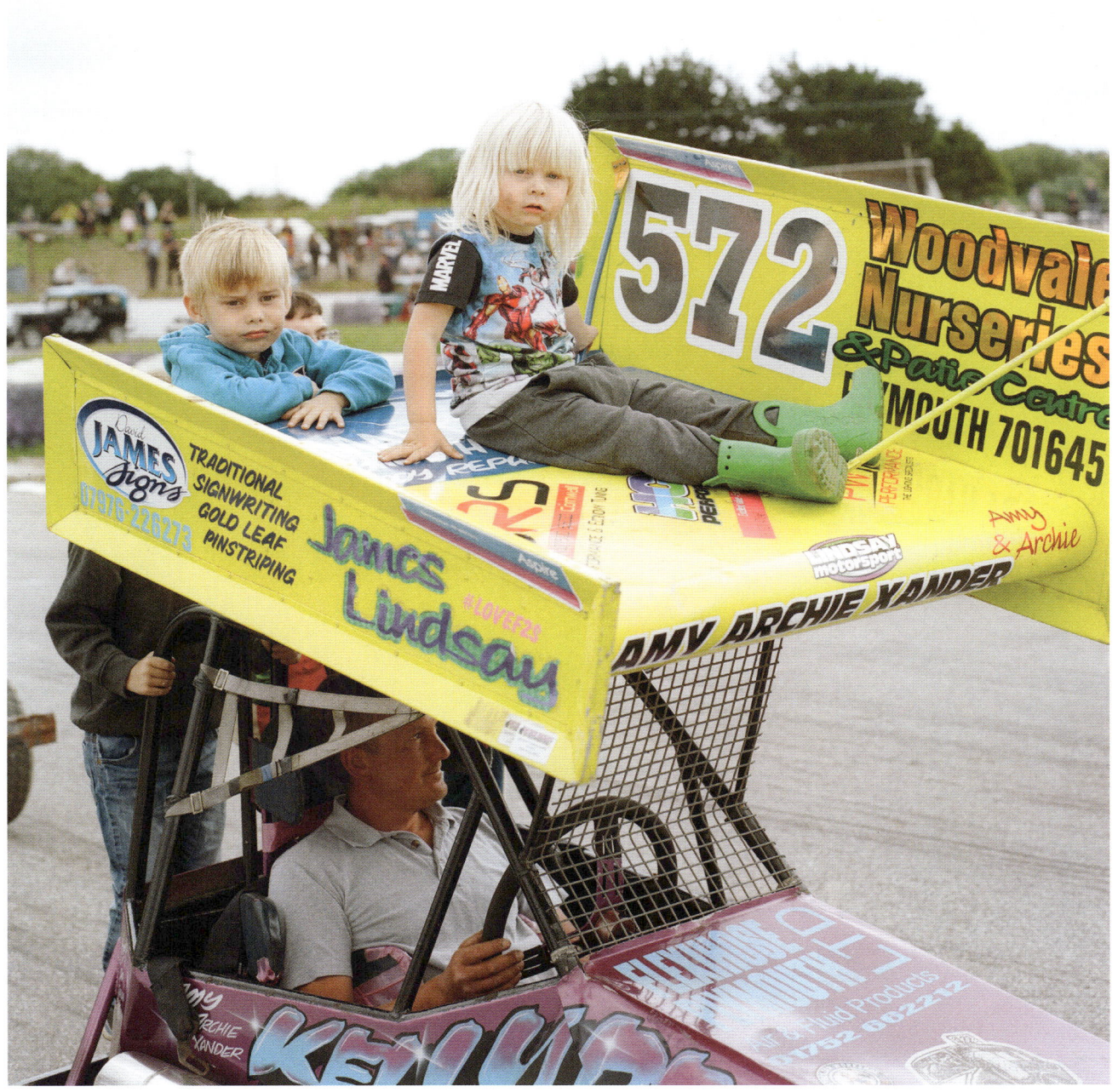

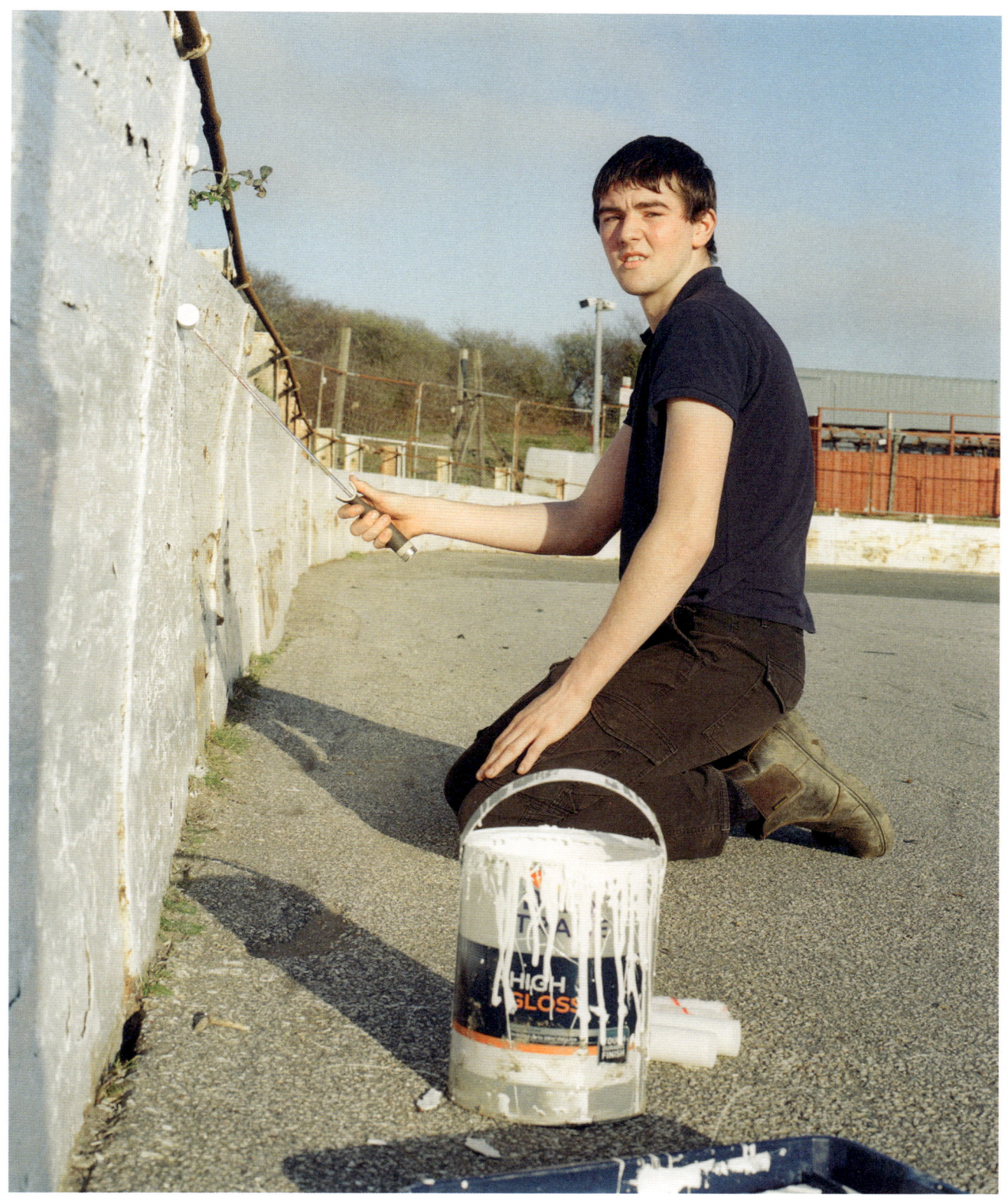

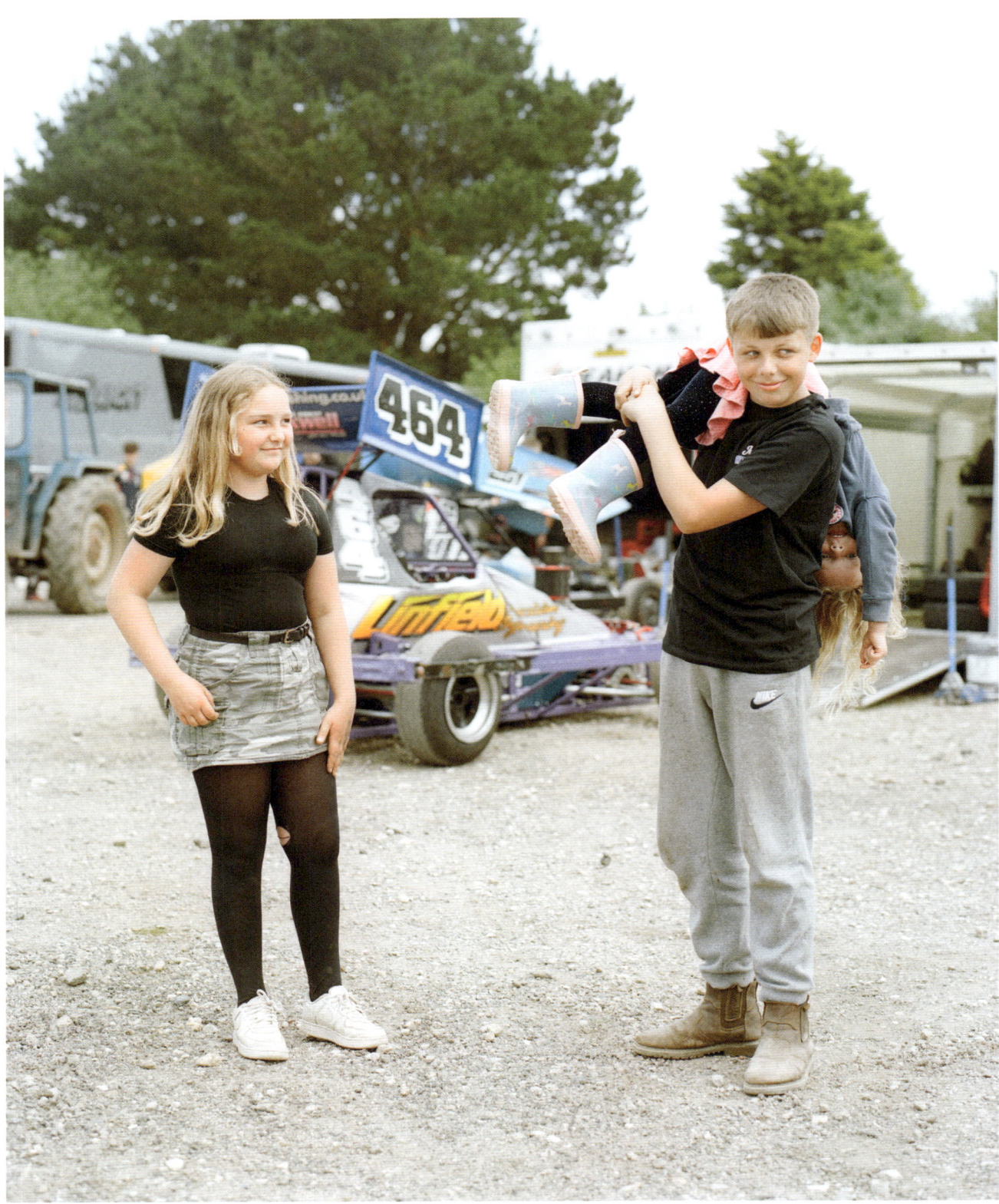

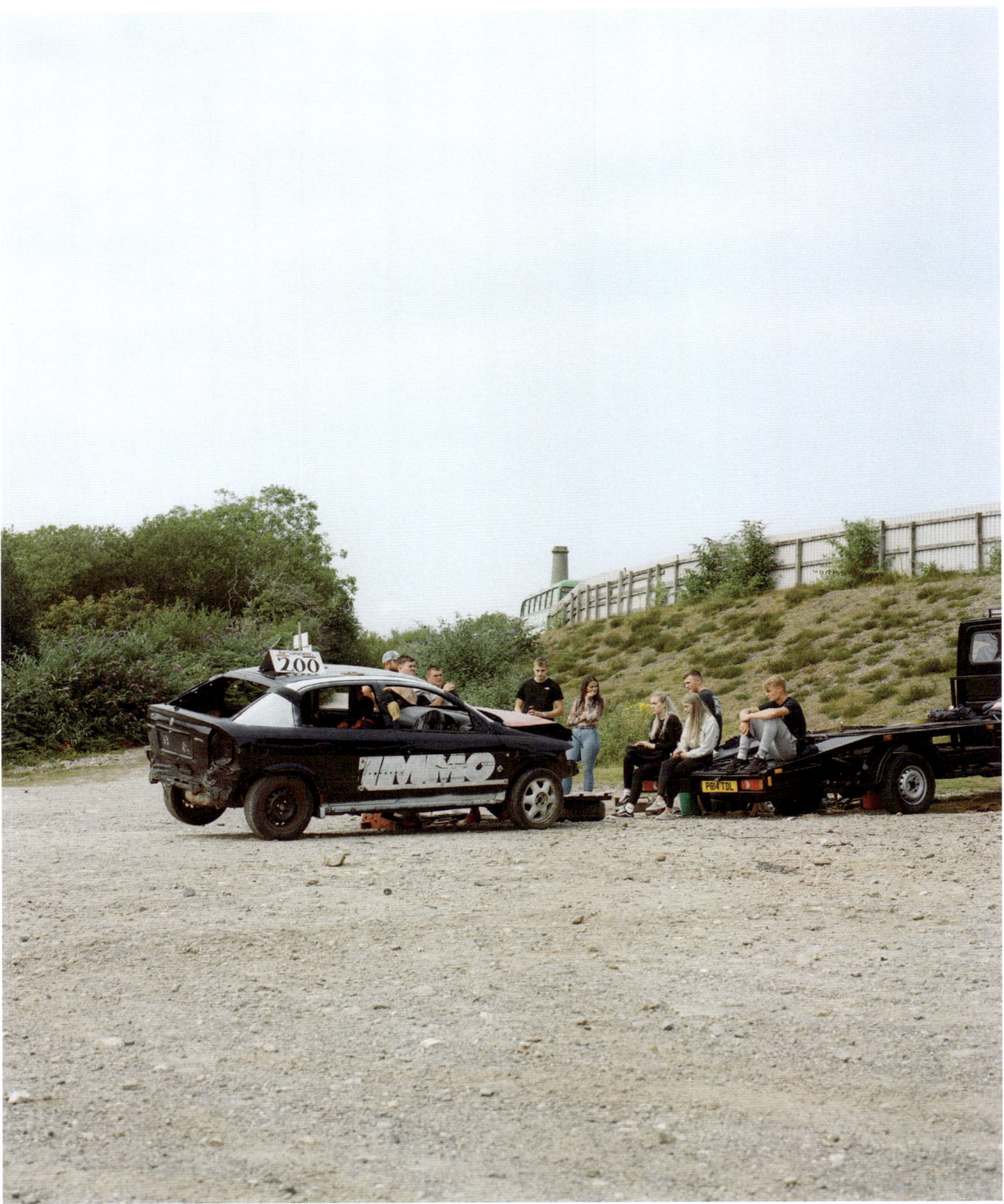

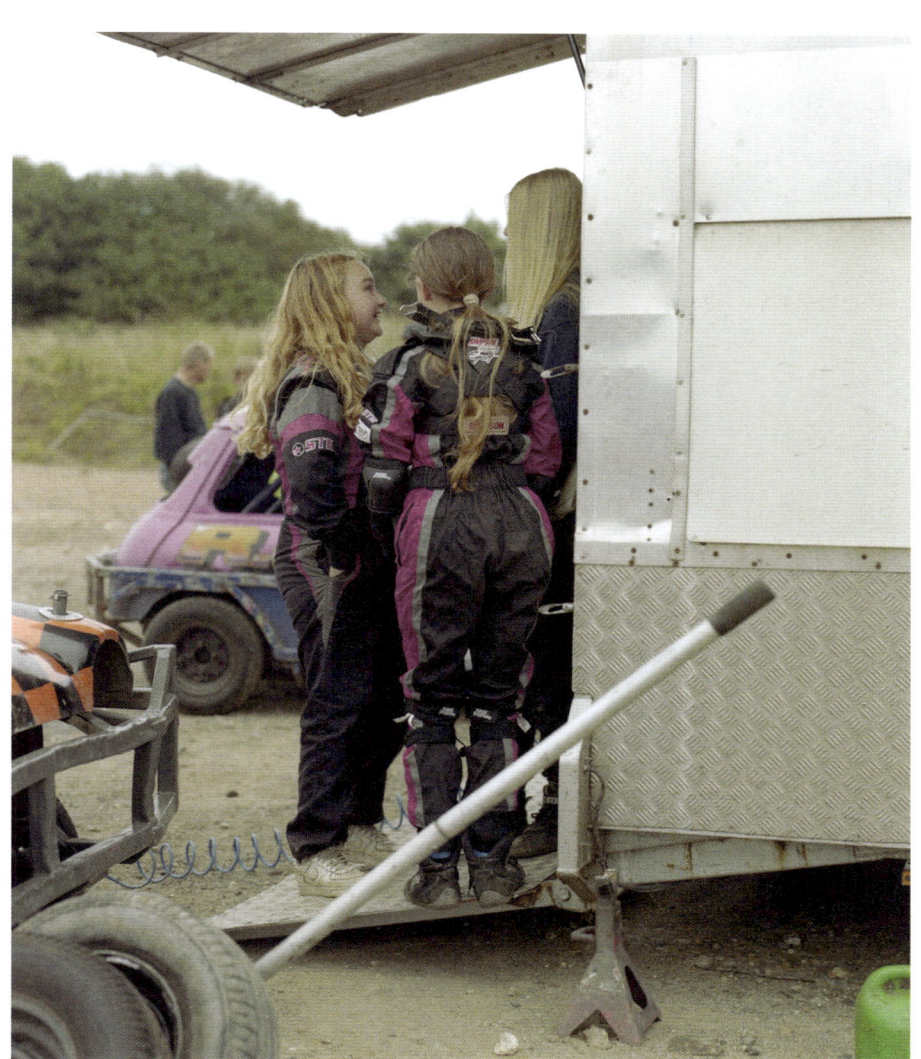

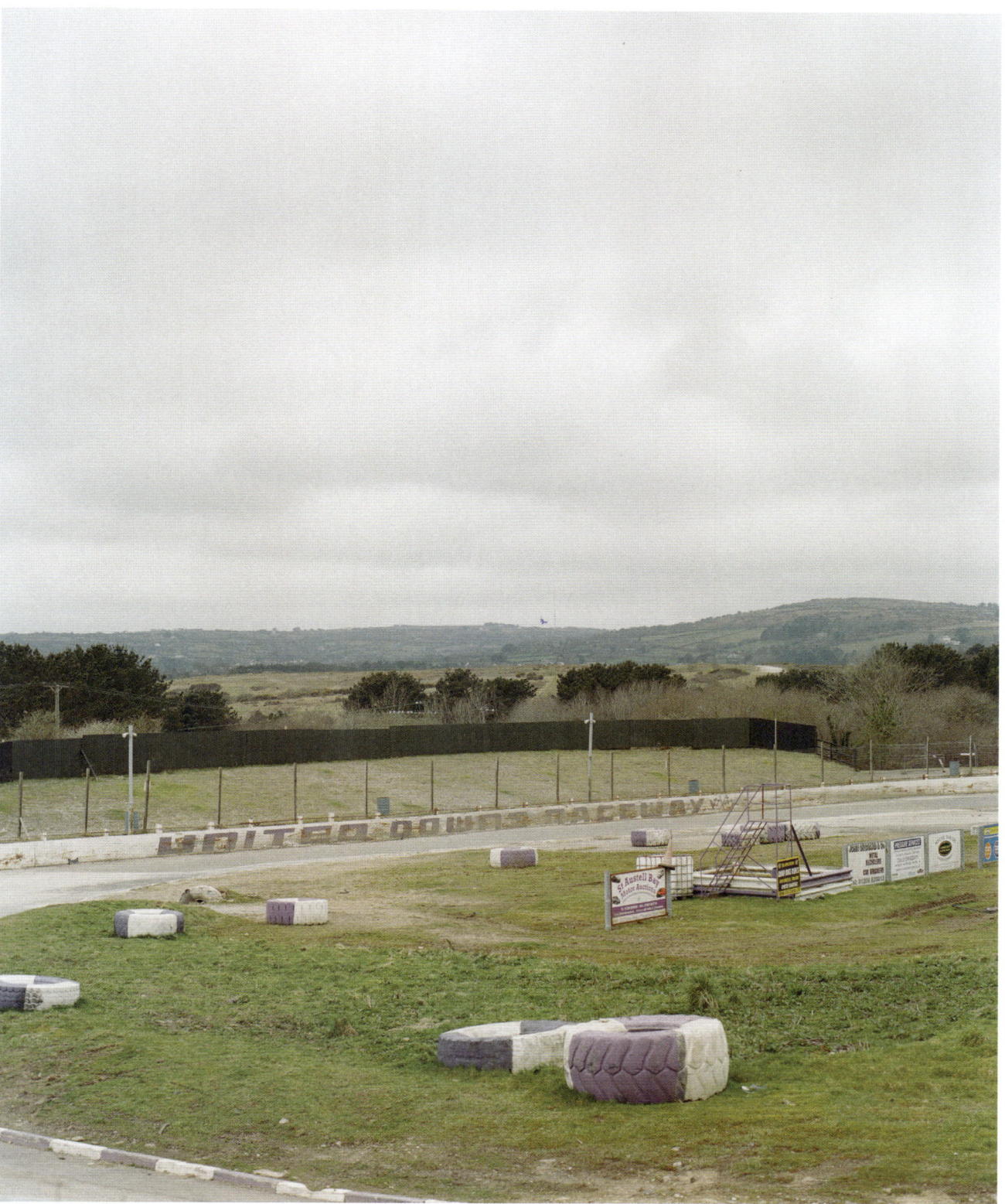

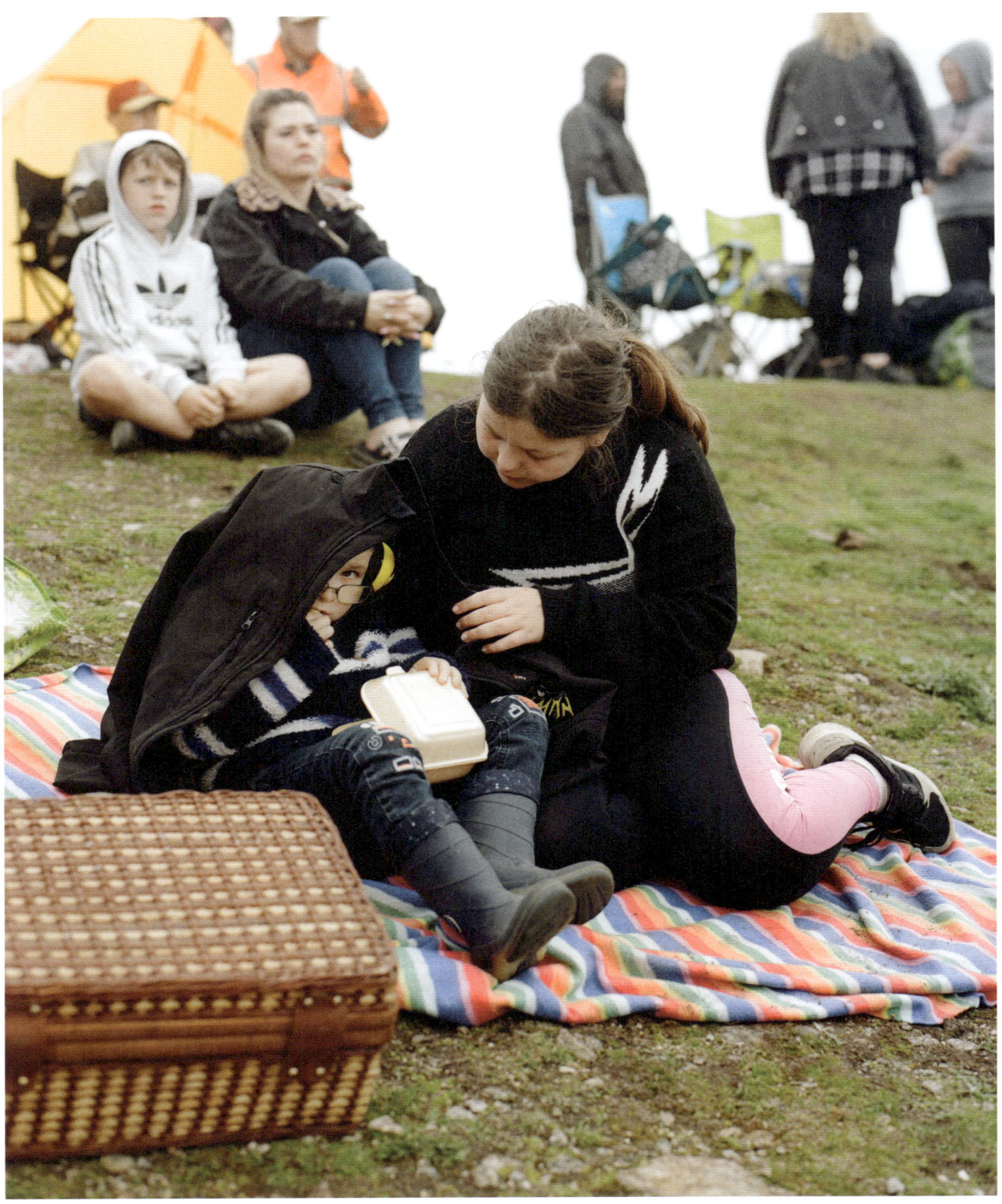

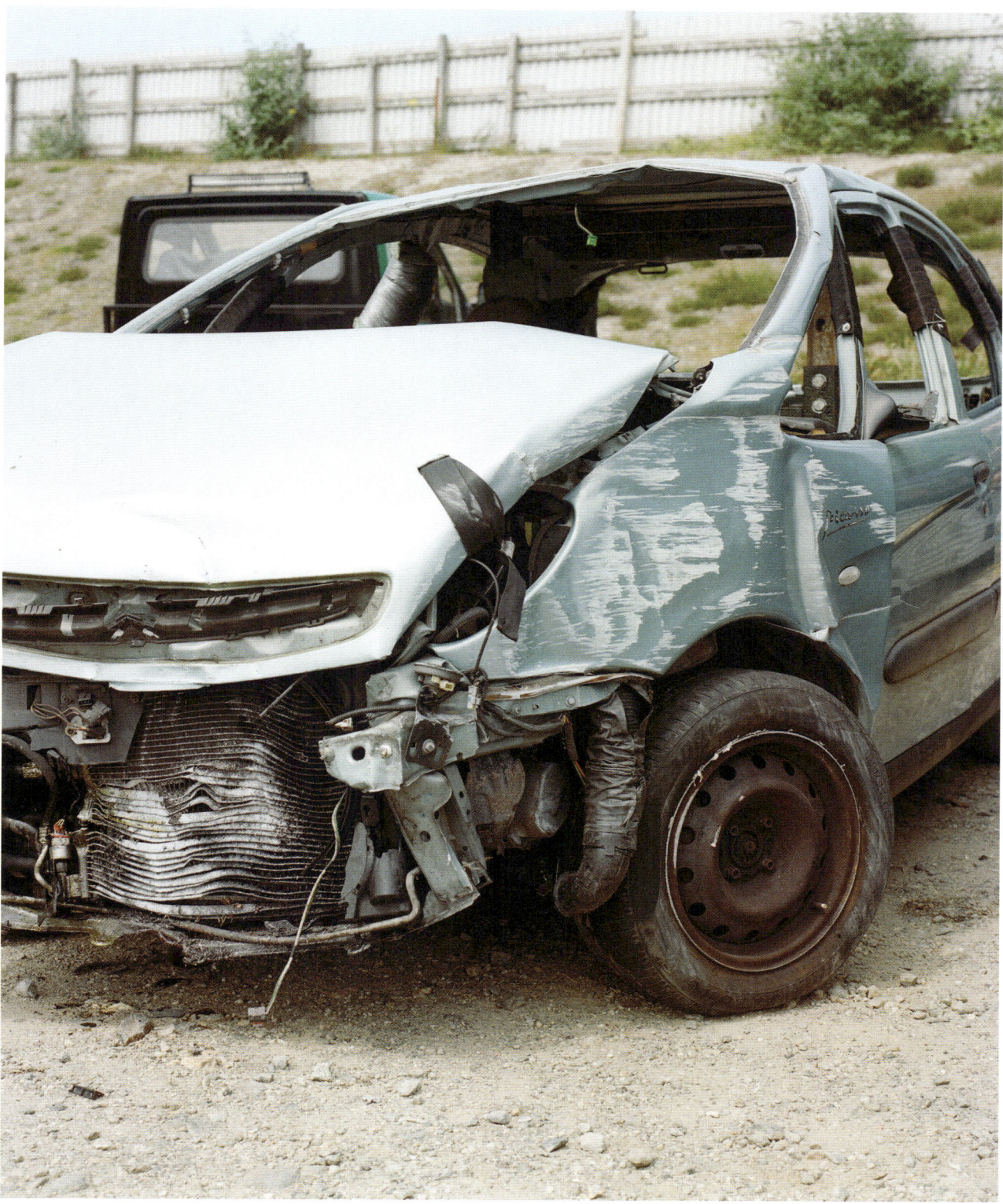

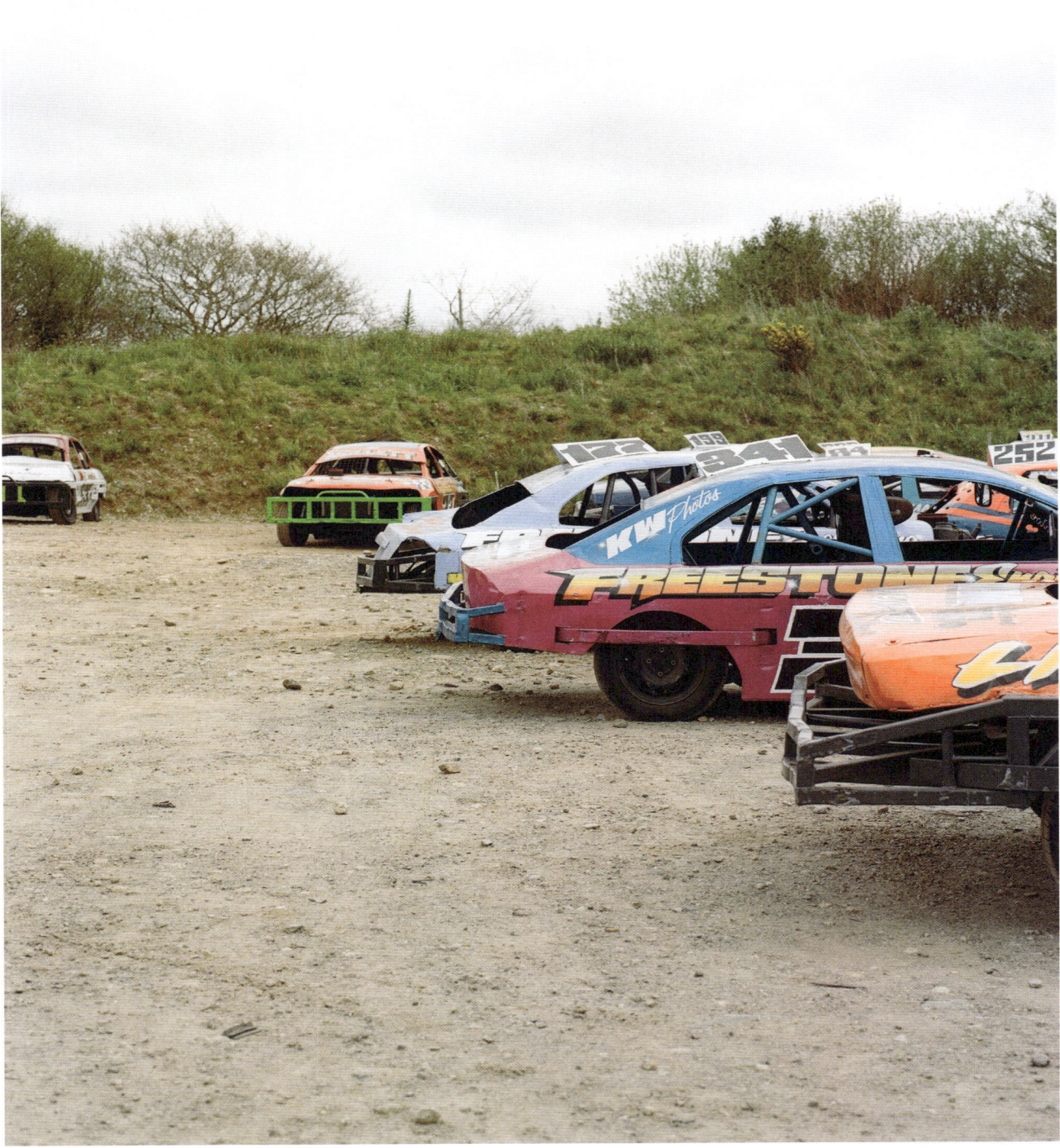

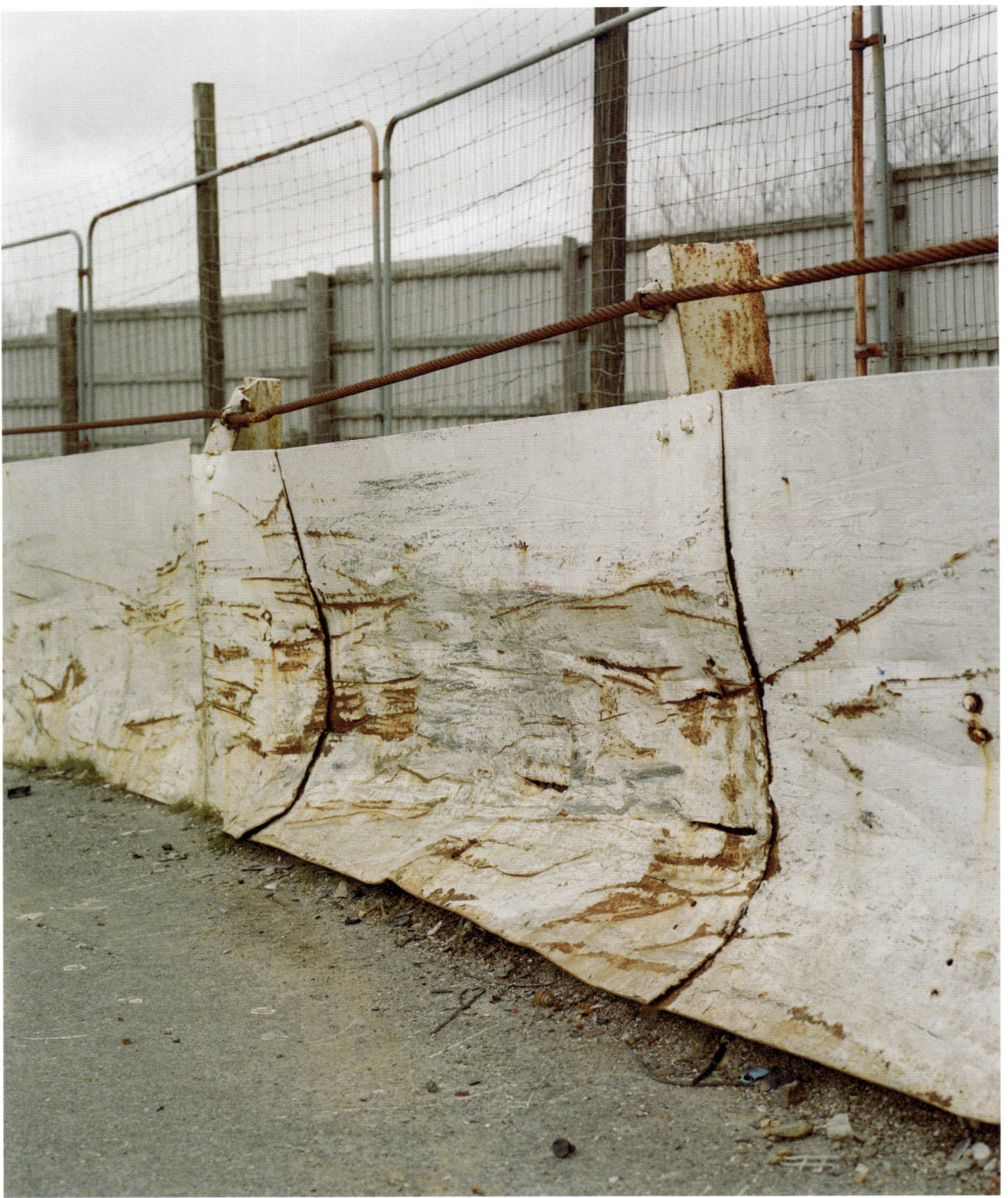

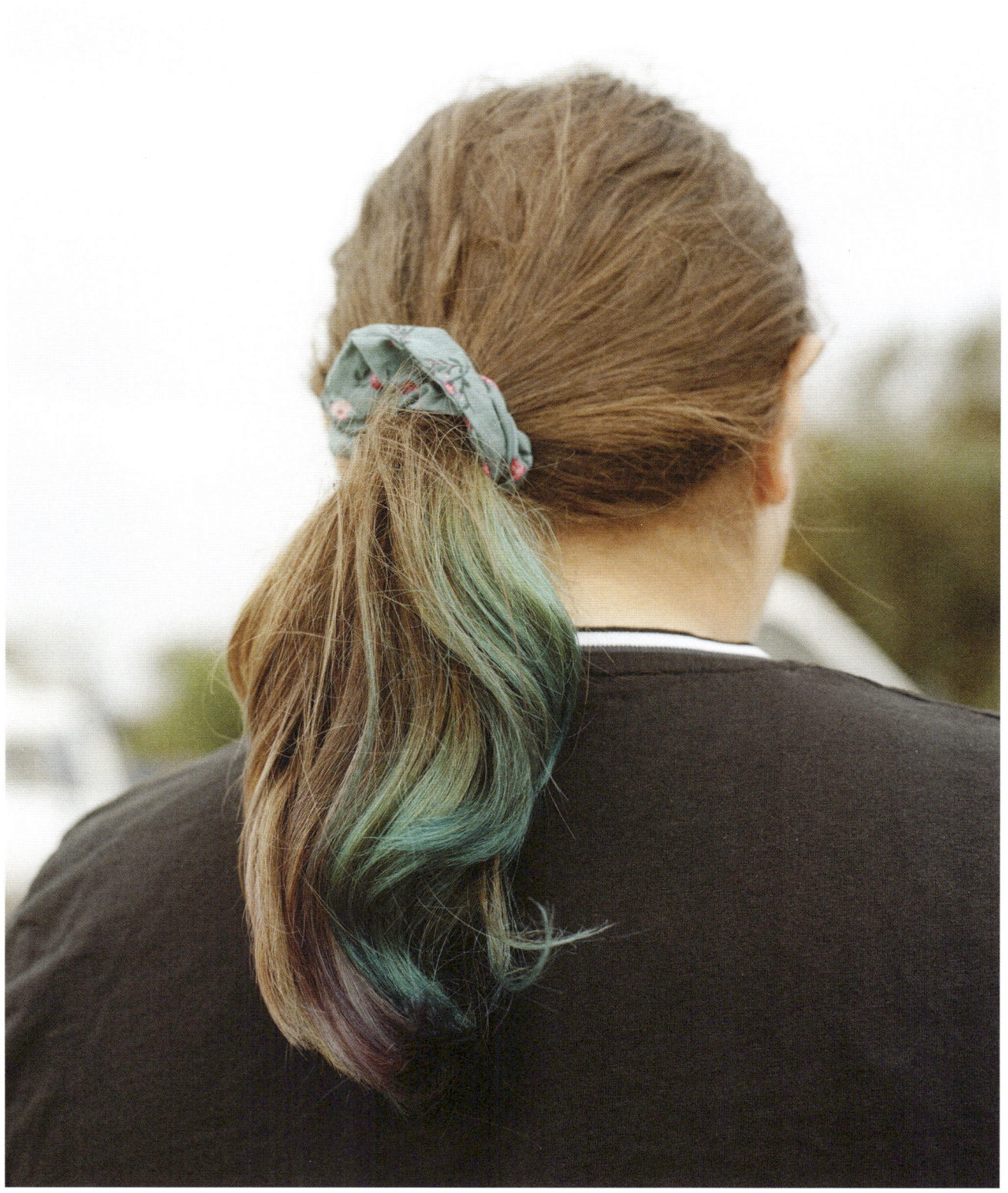

THE LAST RACEWAY

CORNWALL'S LAST BANGER AND STOCK CAR RACING TRACK LIES IN THE VILLAGE OF ST DAY. ONE BY ONE TRACKS ARE DISAPPEARING THROUGHOUT THE UK AS THE SUBCULTURE SUCCUMBS TO A SLOW DECLINE. FOR 50 YEARS THE TRACK AT ST DAY HAS BEEN KEPT ALIVE, THROUGH LOVE, DEVOTION AND COMMUNITY, BUT IT NOW FACES ITS TOUGHEST TEST.

THE LAST RACEWAY TELLS THE STORY OF THE TRACK AS IT FACES DEMOLITION, A TOURIST ATTRACTION PLANNED IN ITS PLACE. REGARDLESS OF ITS PHYSICAL FATE, THIS BOOK AIMS TO PROVIDE A HOME FOR THE TRACK, ITS STORIES, AND ITS PEOPLE, IN WHAT COULD BE ITS FINAL SEASON.

BECKY TYRRELL IS AN AWARD WINNING PHOTOGRAPHER LIVING AND WORKING DEEP IN RURAL CORNWALL. HER PRACTICE FOCUSES ON CAPTURING THE PLACES AND PEOPLE IMMEDIATELY AROUND HER. USING PORTRAITURE AND SOCIAL DOCUMENTARY, SHE TELLS THE STORIES OF THOSE LIVING LIFE AT THE END OF THE LINE.

FIRST PRINTING
AUGUST 2022

THE LAST RACEWAY
ALL IMAGES COPYRIGHT
OF BECKY TYRRELL

PUBLISHED BY GUEST EDITIONS
LONDON 2022

PRINTED BY COLT PRESS,
UNITED KINGDOM

DESIGN AND EDIT
THOMAS COOMBES,
GUEST EDITIONS

LONG LIVE UNITED DOWNS RACEWAY

978-1-9162253-8-1

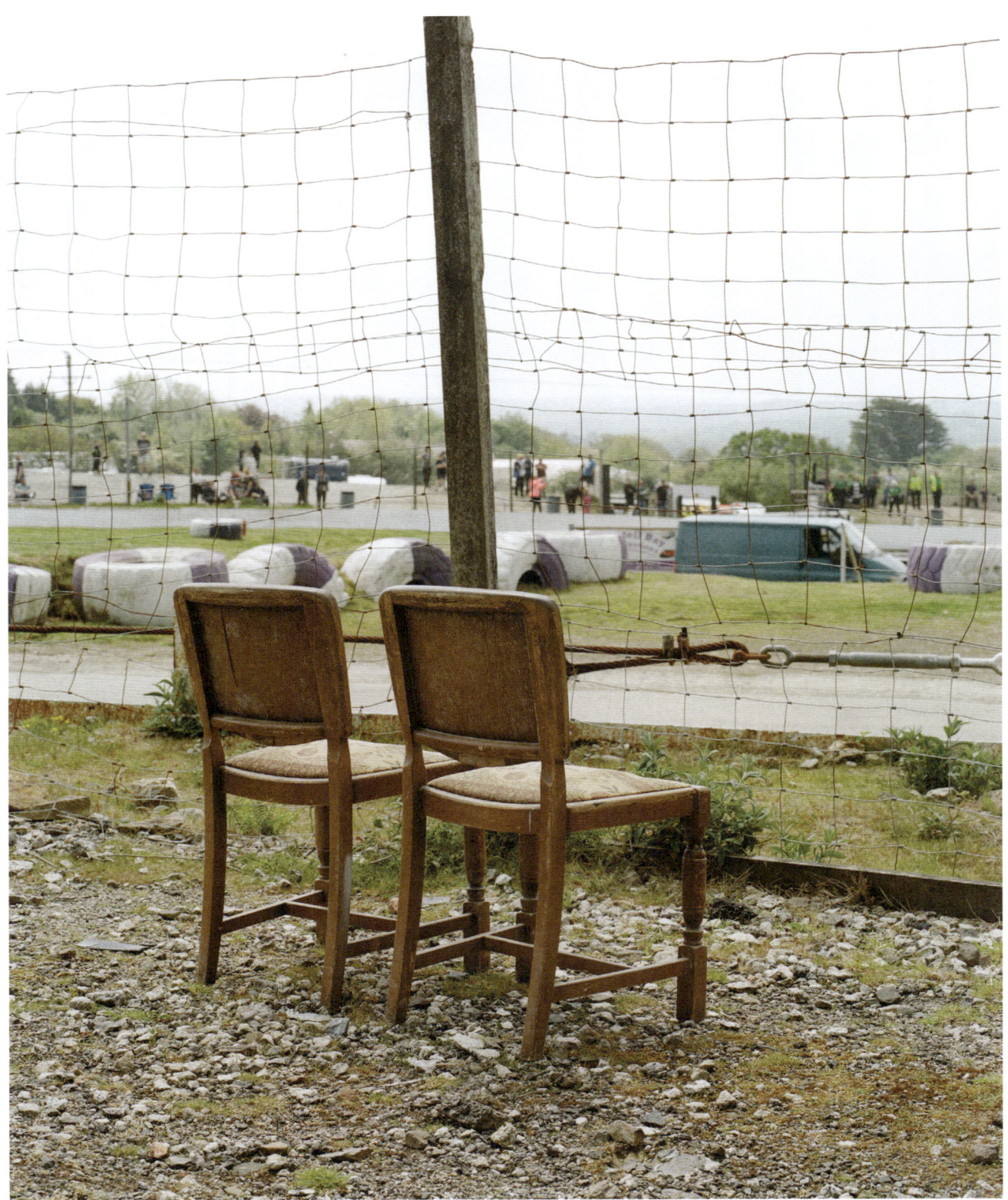